11/5

W9-CJO-562

W9-CJO-562

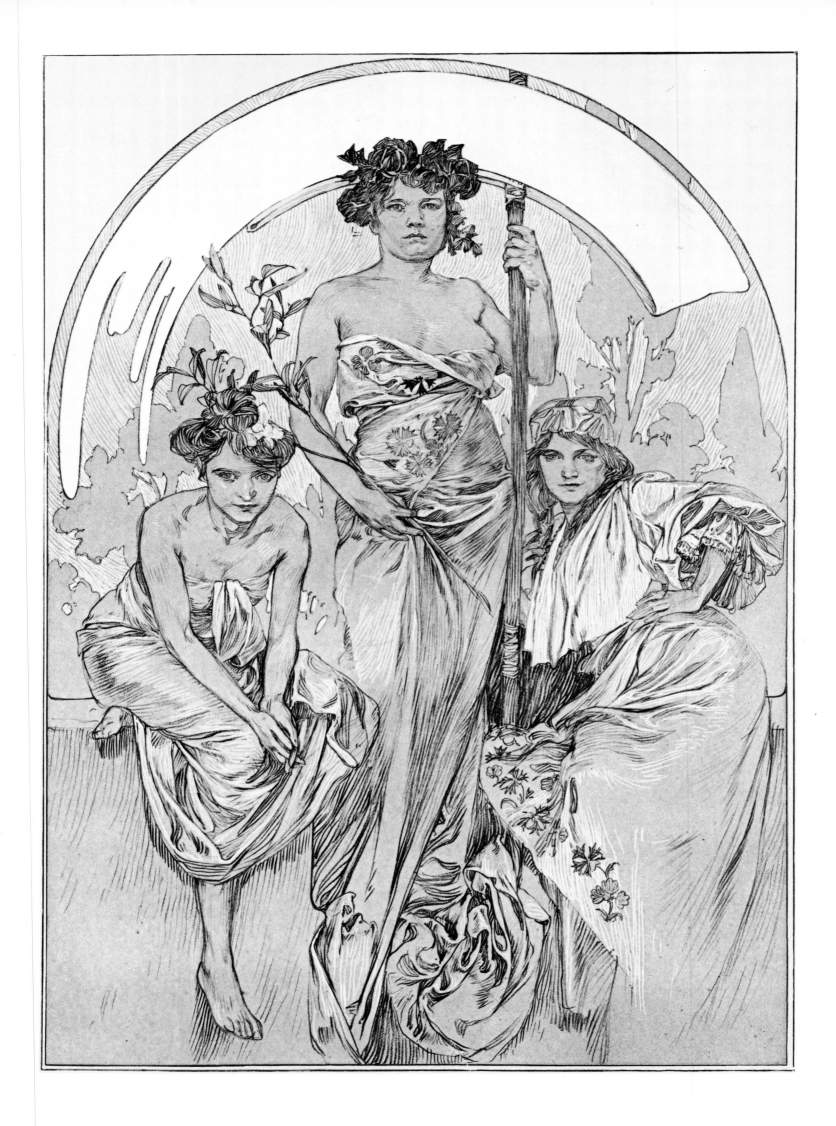

MUCHA'S
Figures Décoratives

40 Plates by Alphonse Mucha

With a new Introduction by
Anna Dvořák

Dover Publications, Inc., New York

Published in Canada by General Publishing Company, Ltd., 30 Lesmill Road, Don Mills, Toronto, Ontario.
Published in the United Kingdom by Constable and Company, Ltd., 10 Orange Street, London WC2H 7EG.

This Dover edition, first published in 1981, is an unabridged republication of the portfolio *Figures Décoratives,* originally published in 1905 by the Librairie Centrale des Beaux-Arts, Paris. Exigencies of production have necessitated a new sequence of the plates and some variations in the additional tints of certain plates. Concordances between original and new plate numbers have been provided.
This edition also contains a new introductory essay by Anna Dvořák.

International Standard Book Number: 0-486-24234-X
Library of Congress Catalog Card Number: 81-68352

Manufactured in the United States of America
Dover Publications, Inc.
180 Varick Street
New York, N.Y. 10014

INTRODUCTION

Alfons Maria Mucha, or Alphonse Mucha, as the French called him, was one of the best-known decorative artists in Paris at the turn of the century. At the end of 1894, he became famous literally overnight with a poster for Sarah Bernhardt's *Gismonda*, a highly original design of an unusually elongated shape, delicate coloring, and a combination of simplified outlines and Byzantine richness of ornamental decoration. In the following decade, Mucha's obsession with curves of long hair coiling around idealized women became the most typical and imitated feature of his numerous posters and *panneaux décoratifs*, and "le style Mucha" gained a lasting international reputation.

Surprisingly, the artist whose name became synonymous with the refined grace of French Art Nouveau was a Czech who was born in 1860 in the small Moravian town of Ivančice and died in 1939 in Prague. Moreover, he was a more complex and interesting artistic personality than the widely reproduced women and flowers imply. When we regard his *oeuvre* in its entirety, we find that he was not only a superb poster artist and unexpectedly versatile designer, but also a gifted and innovative illustrator, a memorable teacher, and a painter who hoped to be remembered not for the "fashionable vagaries" that were in such demand, but for his murals and monumental paintings.

Mucha always claimed that chance, or Fate as he preferred to think of it, played an important part in his life. It may have been chance that sent his way his first patron, Count Khuen Belassi of Emmahof, and later in life the American industrialist Charles R. Crane, who enabled Mucha to depict Czech history in the grand manner regardless of the expense and contemporary trends. However, it was most certainly Fate that interrupted his gradual development as a history painter in the academic tradition, dramatically changed his career, and enabled him to establish himself very rapidly as the foremost Art Nouveau artist in Paris.

The breakthrough came with *Gismonda*, Mucha's first poster for Sarah Bernhardt. He got the commission by a stroke of incredibly good luck simply because he was the only artist present in Lemercier's printing shop on December 26, 1894, when the great actress called and ordered a new poster for her play. Mucha was catapulted to fame by his first work for her, and considering the formidable competition in the field of poster design of the nineties, his achievement was impressive. He succeeded in creating *affiches* that were both in design and coloring unlike any other posters on the billboards, and from the beginning was considered not a follower, but an equal of the best poster artists of the period.

Of all the contemporary influences, it was probably the power of Bernhardt's personality and the emotional force of the scene in which Mucha chose to depict her for the *Gismonda* poster — on her way to church, in a Byzantine setting — that triggered the beginning of his new style.[1] On the stage, the Divine Sarah was not a woman but a symbol, an unattainable dream, and Mucha's unusual posters were uniquely appropriate to this famous actress who had the ability "to touch even a classical French drama with the oriental, the strange, and the exotic."[2]

Under a six-year contract with Bernhardt, Mucha designed for her nine exquisite posters and cooperated with her closely on the production of several plays, including *La Princesse lointaine* by Edmond Rostand and *La Dame aux camélias* (Camille) by Dumas *fils*. At the same time, he was bound by a contract to the printer Champenois to design for a fixed salary as much graphic work as the printer required, and their cooperation led to some of Mucha's best-known lithographic work, including the enormously popular *panneaux décoratifs* of *Four Seasons*, *Four Flowers*, *Four Stars*, and *Four Precious Stones*.

In the light of Mucha's extraordinary success in the decorative arts, it is easy to overlook the fact that during his long artistic career there were only very few years when his interest in monumental projects was dormant, and that large symbolic paintings were always a part of his exhibitions. Such ambitious works began in the 1880's with the frescoes at Emmahof, Moravia. They were followed by the murals for the pavilion of Bosnia and Herzegovina at the 1900 Paris World Exhibition, the interior design of the German Theater in New York in 1908, and a year later by the mural decorations of the Municipal Building in Prague. These paintings were stepping-stones to a project that had become Mucha's *idée fixe* and that occupied the artist for the last twenty-five years of his life. The twenty enormous canvases of the *Slav Epic*, a pictorial history of the Slav race, constitute his greatest achievement as a history painter.

While the murals and oil paintings represent the results of Mucha's most important and least-known ambitions, his book illustrations indicate the scope of his widely diversified artistic achievements. They reflect the artist's stylistic development over some forty years, reveal the multifaceted character of his talents and interests, interconnect his early professional training with the monumental can-

1 Jiří Mucha, Marina Henderson, and Aaron Scharf, *Alphonse Mucha: Posters and Photographs* (London: Academy Editions, 1971), p. 37.

2 Charles Hiatt, "Sarah Bernhardt, Mucha, & Some Posters," *The Poster*, 2 (1889), p. 238.

vases of his later years, and help to illuminate his approach to decorative arts.

The illustrations for *Album historique* by Parmentier, and especially for the *Scènes et épisodes de l'histoire d'Allemagne* by Charles Seignobos, helped Mucha to establish a reputation as an artist with a definite affinity for history painting. *Ilsée, princesse de Tripoli* by Robert de Flers is his most complete statement in the Art Nouveau style, while Mucha's *Le Pater* combines all the virtuosity of decorative design displayed in *Ilsée* with monochrome figural scenes that point to his own ties with the Symbolists. *Documents décoratifs* and *Figures décoratives* are his most comprehensive textbooks of Art Nouveau design. They reflect Mucha's interest in art education in schools, and document his conscientious effort to spread good design among the masses. These two textbooks for designers are a culmination of Mucha's work from 1895 to 1905, the decade that made him famous. As they sum up his complex achievements as a decorative artist in the new style, their importance cannot be overestimated.

In branching out into various fields of decorative design, Mucha was following a general trend. The tendency of Art Nouveau toward a synthesis of various genres of art brought about the appearance of the "universal artist" who worked in a number of different media, for various purposes and in various fields. Many of these artists not only produced designs for every imaginable object, but also were interested in the theory of Art Nouveau as a style of living.

Mucha most certainly was not a *doctrinaire* like Henry van de Velde who took care that his wallpaper, his furniture, his wife's dresses and jewelry and even the color of the food served to his guests were an integrated part of the total decorative scheme of his house. In comparison, Mucha's studio in rue du Val-de-Grâce resembled, according to contemporary visitors, a cross between a museum and a bazaar and was filled with hundreds of objects that had been used as props in his paintings and never discarded. Contemporary photographs of the atelier show draperies and embroidery, paintings and posters, Persian carpets, bear and tiger skins, palms, musical instruments, stuffed birds and a medley of furniture of various styles in a combination that would have been unacceptable to any Art Nouveau purist.

Nevertheless, Mucha's decorative designs were pure Art Nouveau, and the list of his entries for the 1900 Paris World Exhibition documents both his productivity and his versatility. He exhibited about twenty-five *panneaux*, all the posters for Sarah Bernhardt, calendars, and illustrated books. He painted murals, and was awarded a medal for sculpture. Objects exhibited by various firms after Mucha's designs included carpets, fabrics, furniture, and, above all, jewelry for which the jeweller Fouquet received several awards.

In fashionable society, Mucha's work was in such demand that it was difficult for him to meet all the requests from his patrons. In addition, the artist felt it a duty to make his designs widely accessible. Finally, he had what he considered a brilliant idea:

> I decided to publish a special work containing decorative elements and items where these elements could be used so that everybody would find what he wanted ready made. At the end there were two works: *Documents décoratifs* and, five years later, *Figures décoratives,* and they were not my first works of this kind either. . . . *Documents décoratifs* contained a number of motifs, some of them in color for two-dimensional and plastic exploitation. The enterprising publishers sold the work to schools and libraries of nearly all countries of Europe, and I think it made some contribution towards bringing aesthetic values into the arts and crafts.[3]

Published in 1902 by the Librairie Centrale des Beaux-Arts with a preface by Gabriel Mourey (and reprinted in its entirety in 1980 by Dover Publications under the title *The Art Nouveau Style Book of Alphonse Mucha*), *Documents décoratifs* is an encyclopedia of Mucha's decorative work. The folio of seventy-two sheets contains not only finished designs of innumerable objects that may be used by manufacturers, but also examples of the process of stylization from an analytical study to an object for practical use.

Mucha's lessons for the graphic artist include studies of nudes, of draped models, and of heads. As in the later *Figures décoratives*, he incorporates each figure into a particular shape—a circle, triangle, crescent or rectangle. Further examples show a combination of these forms and their pictorial content with ornament and lettering, and the effectiveness of a three-dimensional figure placed in front of the flat ornamentation of the background.

From Mucha's posters and *panneaux*, it is obvious that Nature played a prominent role in his art. He seems to have shared with the French Art Nouveau artists not only a special *rapprochement* with Nature, but also a growing belief that the trend in art should be "away from the imitative reproduction of Nature, towards an abstract and re-fashioned interpretation,"[4] and some of his *études* offer a step-by-step instruction in this direction.

He may start with a naturalistic study of a plant, flower or fruit—for example, a cluster of berries from the mountain ash—and through simplification and stylization slowly progress to a design for a useful object. To prove that the stylistic approach is influenced not only by artistic criteria but also by the material used in making the objects, he often uses identical motifs through a whole page of designs for embroidery, leatherwork, and metalwork.

Although Mucha himself did not live in a stylistically homogeneous environment, he was quite capable of designing a complete household in compliance with the laws laid down by Henry van de Velde. Designs for tableware include menus, glassware, china on which animal and plant motifs were used in continuous bands, various serving implements, and a set of flatware with the typical Mucha whiplash line on the handles. The interior was thought out to the smallest detail, not only to the fabrics and wallpaper, but literally to the brass tacks.

During the years of his collaboration on Sarah Bernhardt's productions, Mucha designed for the actress several pieces of beautiful and imaginative jewelry. *Documents décoratifs* contains similar designs of pendants, brooches and hair combs, where either the whiplash line, the floral

3 Jiří Mucha, *Alphonse Mucha, His Life and Art* (London: Heinemann, 1966), p. 230.

4 Stephan Tschudi Madsen, *Sources of Art Nouveau* (New York: Wittenborn, 1955), p. 167.

motifs, or a woman's face with masses of hair is used as decoration. Very similar designs can be found in the silverware of Unger Brothers, Newark, N.J., and although the firm might have followed only a general trend, there is no doubt that Mucha's book was available in the United States, and that it may have had the influence he hoped for.

With *Documents décoratifs*, Mucha established himself as a decorative artist *par excellence* at a time when he began to be weary both of the posters and of decorative arts. The publication, a summary of his widely diversified design in the Art Nouveau style, was meant as a definitive work which should finally enable him to turn his attention to other projects. He hoped that his prospective clients would be willing to choose anything they needed from his book, but he was mistaken:

> I thought that now I would be left in peace. But what an anticlimax. Someone wanted a piece of jewelry of unique design and value. He wrote to me: "I saw in your book *Documents décoratifs* a very nice pendant. I would like to have one like it — but a little different." Another man wanted cutlery: "The same, but a little different." Another a vase, another a lamp. Soon I became the victim of my own plot.[5]

Mucha also regarded himself as a victim of his own success when a contract with the publisher Émile Lévy forced him to complement *Documents décoratifs* with another publication, *Figures décoratives*. The portfolio was published in 1905 by the Librairie Centrale des Beaux-Arts in Paris, and contained forty plates aimed at graphic designers rather than the general public.

In *Figures décoratives*, Mucha used exclusively the human figure. Over a period of four years, he produced a pattern book in which the human body, in endless variations of poses, is incorporated into various geometric forms. Placed in rectangles, triangles, stars, circles, and a number of irregular forms are figures of women, young girls, children. The majority of the plates concentrate on female models in a great variety of poses. The artist recorded them sitting, reclining, leaning against each other, resting on a studio chair, or in an imaginary segment of nature. The figures are nude, partially wrapped in intricately draped fabrics, or completely clothed. The skill and obvious ease with which Mucha's pencil followed the outstretched arm, the sway of the hips, the foreshortening of the bent leg is surpassed only by the mastery with which he drew hands. His critics pointed out as early as 1897 that Mucha's hands were often more expressive than the rendering of eyes or faces, and after the publication of *Figures décoratives* the reviewers repeatedly commented on the high quality of his draughtsmanship, the beauty and harmony of line. Some observed that the Slav origin of many of the models lent them an exotic air, seductive and charming.[6]

The plates of *Figures décoratives* exemplify the qualities that predisposed Mucha for success both as an illustrator and as a teacher. His marvellous instinct for composition and a gift for decoration were based on a profound knowledge of his craft, and he was able to impart this knowledge to his pupils. His students in Paris, New York, and at the Chicago Art Institute watched him in amazement and awe as he illustrated his lectures by drawing figure after figure on large sheets of paper in front of the class. Plates 9, 13, 20, and 24 may well have been made at such occasions. Plate 26 includes a figure which in 1905 was used on a prospectus for the course "Mucha" at the New York School of Applied Design for Women.

Several other plates include drawings that were either preliminary studies or finished designs for published works. Plate 5 contains a seated female figure which Mucha utilized as a cover design for *The Index* of July 1, 1905. The plates in *Figures décoratives* present a wealth of other examples illustrating Mucha's approach to small graphic commissions. Like other artists of his time, he designed not only numerous magazine covers, but also theater programs, invitations, and menus, many of which were included in Léon Maillard's *Les Menus et programmes illustrés* of 1898. Each flawless combination of a figure, ornament, and lettering was based on such preliminary studies as can be seen on Plate 7.

Flowers and plants were an integral part of Mucha's *panneaux* and many of his posters. Precise naturalistic studies of plants for M. P. Verneuil's *Encyclopédie artistique et documentaire de la plante* of 1904 reveal the attention Mucha paid to all parts of a plant and all stages of its life. In his most cherished book, *Le Pater*, they are used for their symbolic meaning. In *Documents décoratifs*, the chosen degree of stylization transforms them into wallpapers, lace, or jewelry designs. Throughout *Figures décoratives*, flowers, luscious, palm-like greenery, and clusters of trees appear with considerable frequency. Plates 3, 15, 16, and 27 are reminiscent of Mucha's use of vegetation in the illustrations for Théophile Gautier's *Mémoires d'un éléphant blanc*, and Xavier Marmier's *Les Contes des grand-mères*. The only specific part of nature which is stylized in a very similar manner in the drawings and finished graphic work is the trees spreading their several slim trunks or branches into a sweeping half-circle in Plates 2, 8, 20, and 34. Their forms frame the figure and contain it in a space somewhat similar to a nimbus, a shape to be found in many of Mucha's poster designs.

An unexpectedly large number of drawings concentrates on portraits of children. In Mucha's graphic work, children appear rarely. Among the several available examples are the Christmas party invitation for Sarah Bernhardt's grandchildren (1896), the posters *Chocolat Idéal* (1897) and *Loterie Národní jednoty* (1912), the calendar for *Chocolat Masson* (1897), a ten-crown note of the Czechoslovak Republic (1920), and the January cover of *Hearst International* of 1922. In *Figures décoratives*, Plates 6, 22, and 29 attest to Mucha's ability to portray city and peasant children not only with his customary facility, but also with great tenderness and sympathy.

A revealing feature of the book is the frequent and straightforward rendering of folk art from embroideries to complete costumes. From 1902, after the tour of Moravian villages with the sculptor Rodin, Mucha developed an increasing yearning for the country of his origin. Plates 4, 8, 18, 19, 28, 30, and 39 reveal his constant interest in the history of his own people. The young model portrayed in

5 Jiří Mucha, *op. cit.*, p. 230.

6 Lancelot, "Figures Décoratives de A. Mucha," *Art et Décoration*, 17 (Jan.-June, 1905), p. 36.

Plates 4 and 18 was eventually incorporated into one of Mucha's large oil paintings of 1905, the *Madonna of the Lilies* (collection Jiří Mucha). In 1910, the figure of this peasant girl was reproduced in the magazine *Zlatá Praha* (Golden Prague) under the title *Sorrow*.

To the admirers of Mucha's *panneaux*, many of the drawings included in *Figures décoratives* seem to be realistic documentary studies rather than examples of "le style Mucha." The ideal proportions of the bodies, the harmony between the movement of the head, limbs, and drapery, the sense of balance inherent in each pose reveal the essential laws that govern nature. The special charm, the innocent seductiveness, the irresistible attractiveness of Mucha's best-known decorative works seem to be missing. In the *panneaux*, posters, and illustrations, Mucha's unmistakable style emerges only through the ensuing process of stylization. There is a pronounced difference between the first sketch located in the right upper corner of Plate 21, and the vivacious, exaggerated movement of the figure in the *panneau La Danse* of 1898. The similarity of the pose, including the half-moon framing the head, is undeniable, but in spirit, the *panneau* is a completely different work. The same process of simplifying and at the same time exaggerating the sinuous pose, and suffusing it with charm can be detected when we compare the reclining female figure in Plate 14 with the *panneau Rêverie de soir* (Evening Reverie) of 1899. Possibly the closest similarity in pose and spirit can be found between the upper right drawing on Plate 17, and the *panneau Amethyst* from the series *Four Precious Stones*.

Documents décoratifs leads the student step by step through the process of stylization from a realistic study of nature to a finished product in metal, leather, lace, or glass. *Figures décoratives* is not a source of such guidance. It is up to the designer who consults the book to use Mucha's drawings as a point of departure, and to modify, spiritualize, and stylize this document according to his own perception of the subject matter.

These publications were not only comprehensive surveys of various applications of Mucha's particular idiom, but they also marked a turning point in his life. By the time the second book was published, Art Nouveau as a style had begun its swift decline, and Mucha was exploring the possibilities of an entirely new career in the United States.

Today, when interest in the Art Nouveau style is again extremely strong, individual plates from *Documents décoratifs* and *Figures décoratives* are collector's items, and complete sets of the portfolios are very rare. New generations admire their qualities, which were described by a contemporary French critic as *"richesse de vision, fantaisie d'interprétation, parfum d'exotisme, charme tout féminin et délicatesse de stylisation."*[7]

Raleigh, North Carolina　　　　　ANNA DVOŘÁK
June, 1981

7 "Documents Décoratifs par A. M. Mucha," *Art et Décoration*, 14 (July-Dec., 1903), p. 304.

Concordances
Between Old & New Plate Numbers

Dover Edition	Original Edition	Dover Edition	Original Edition	Original Edition	Dover Edition	Original Edition	Dover Edition
Frontis.	13	20	23	1	1	21	31
1	1	21	11	2	2	22	37
2	2	22	38	3	18	23	20
3	29	23	18	4	7	24	8
4	8	24	31	5	9	25	26
5	12	25	35	6	19	26	10
6	9	26	25	7	13	27	12
7	4	27	33	8	4	28	33
8	24	28	20	9	6	29	3
9	5	29	16	10	36	30	11
10	26	30	17	11	21	31	24
11	30	31	21	12	5	32	35
12	27	32	37	13	Frontis.	33	27
13	7	33	28	14	14	34	15
14	14	34	36	15	17	35	25
15	34	35	32	16	29	36	34
16	19	36	10	17	30	37	32
17	15	37	22	18	23	38	22
18	3	38	39	19	16	39	38
19	6	39	40	20	28	40	39

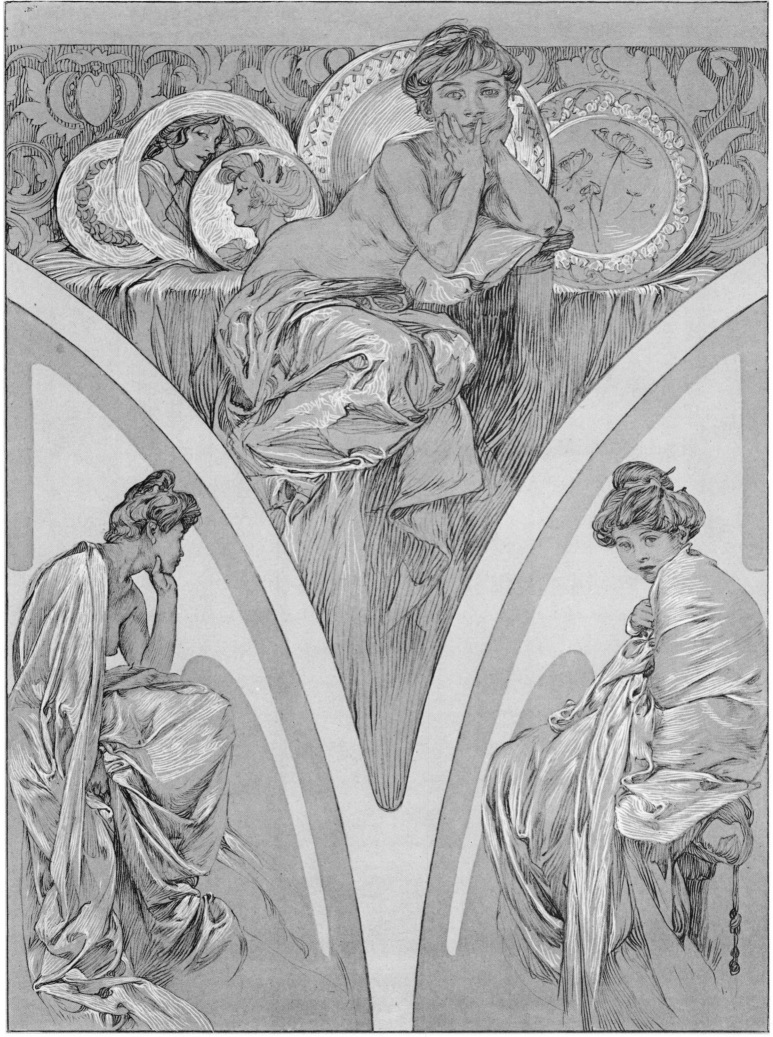

PLATE 1

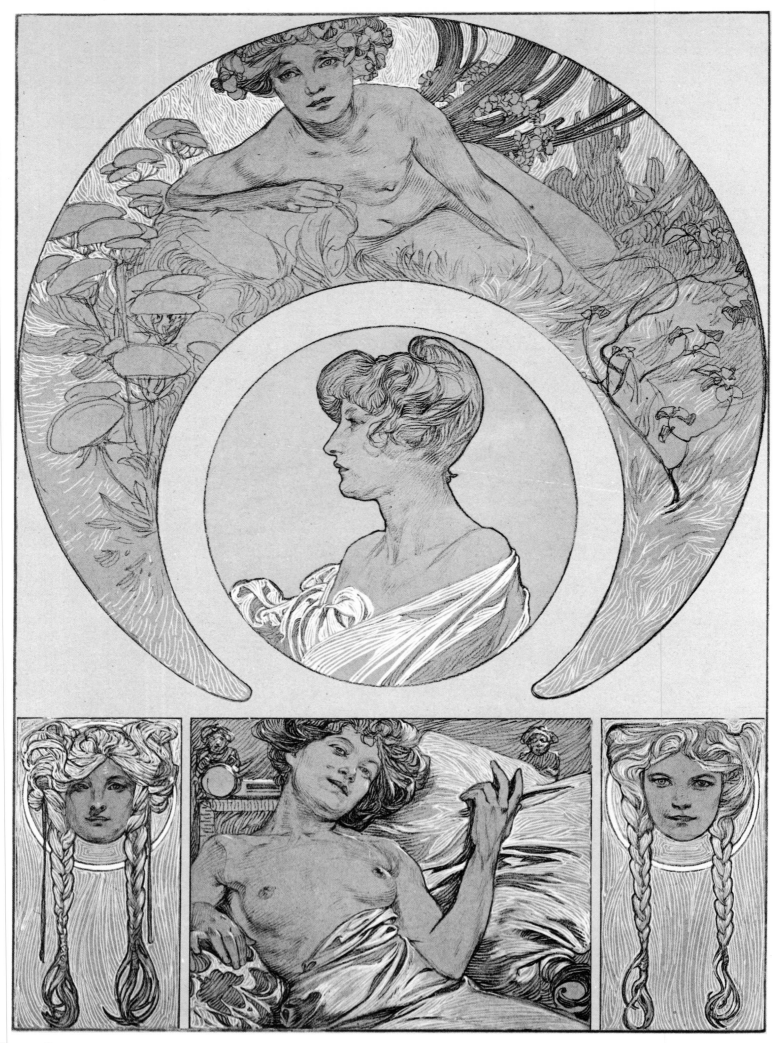

PLATE 2

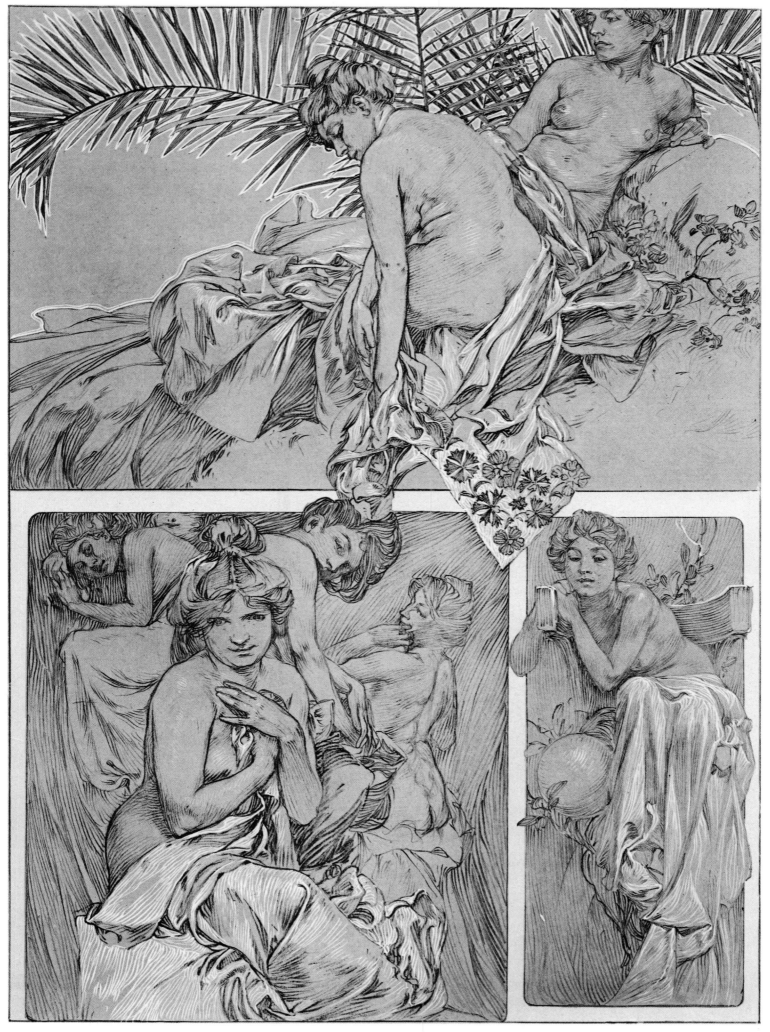

PLATE 3

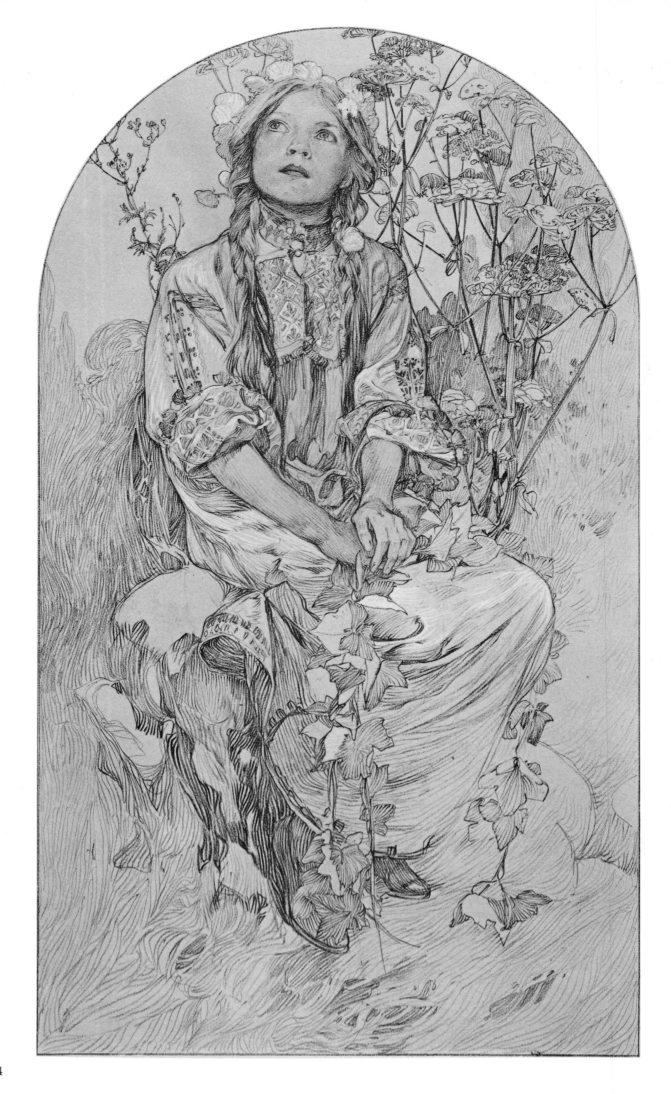

PLATE 4

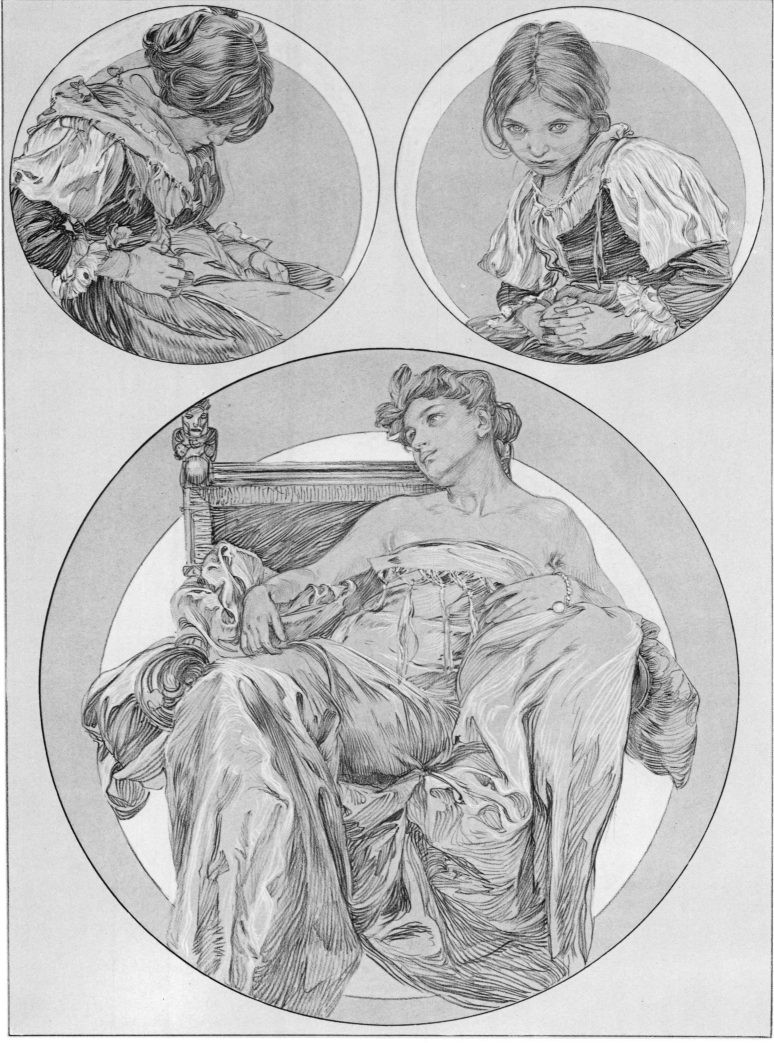

Plate 5

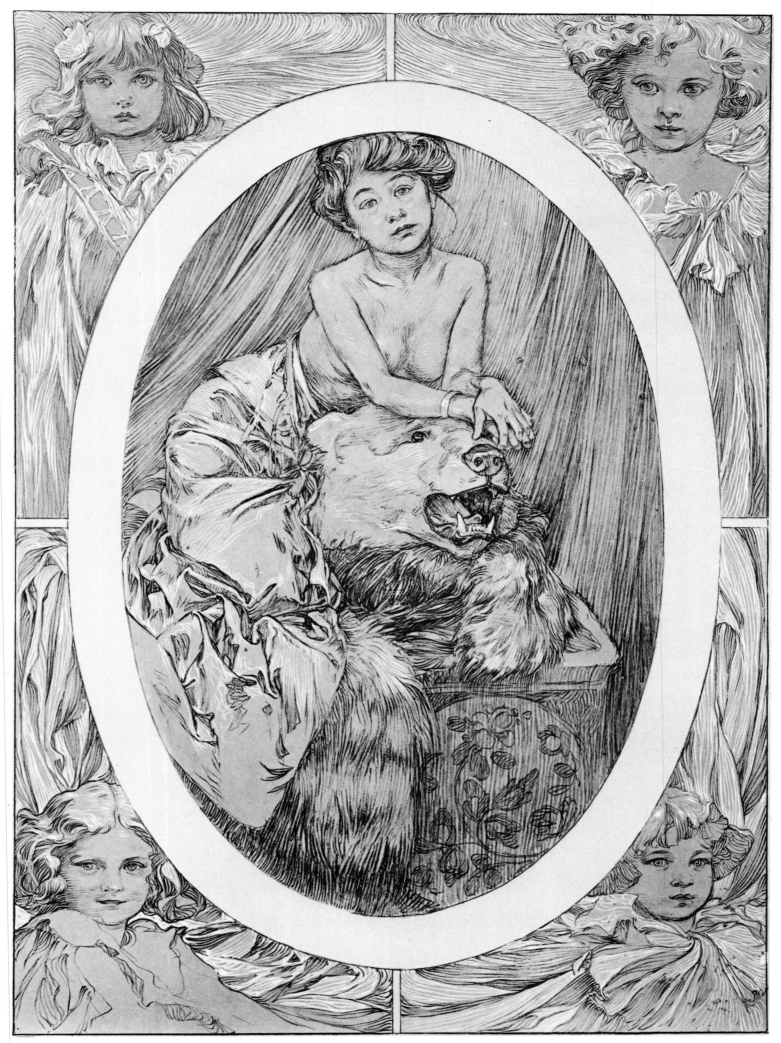

PLATE 6

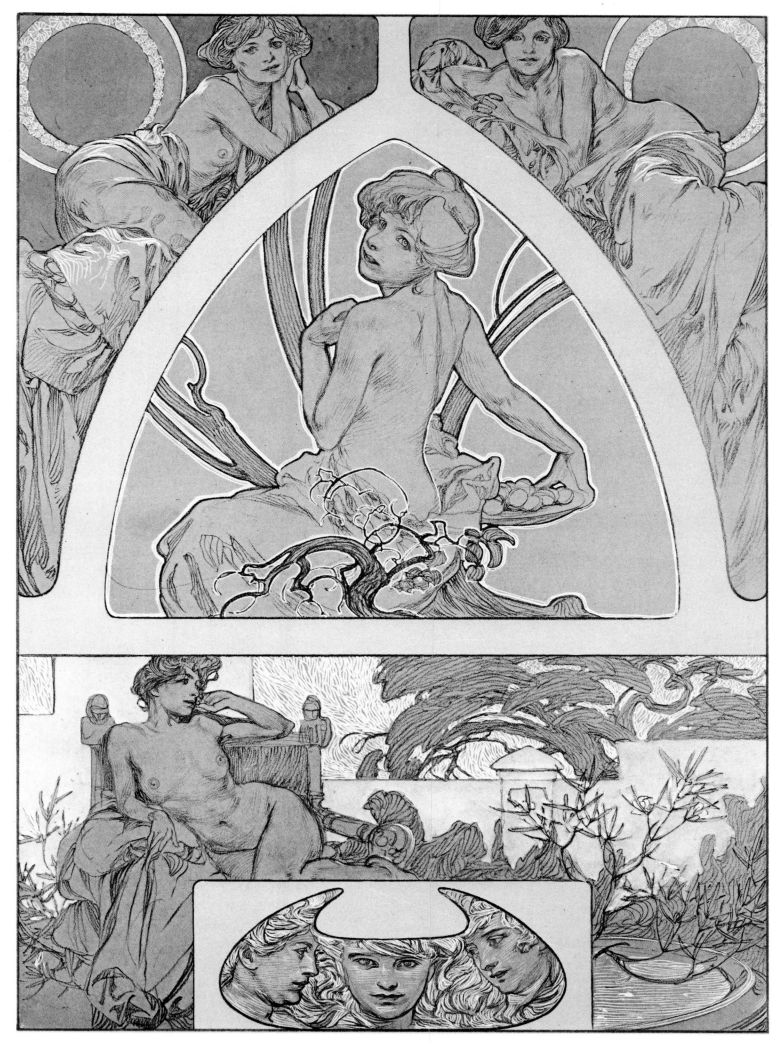

PLATE 7

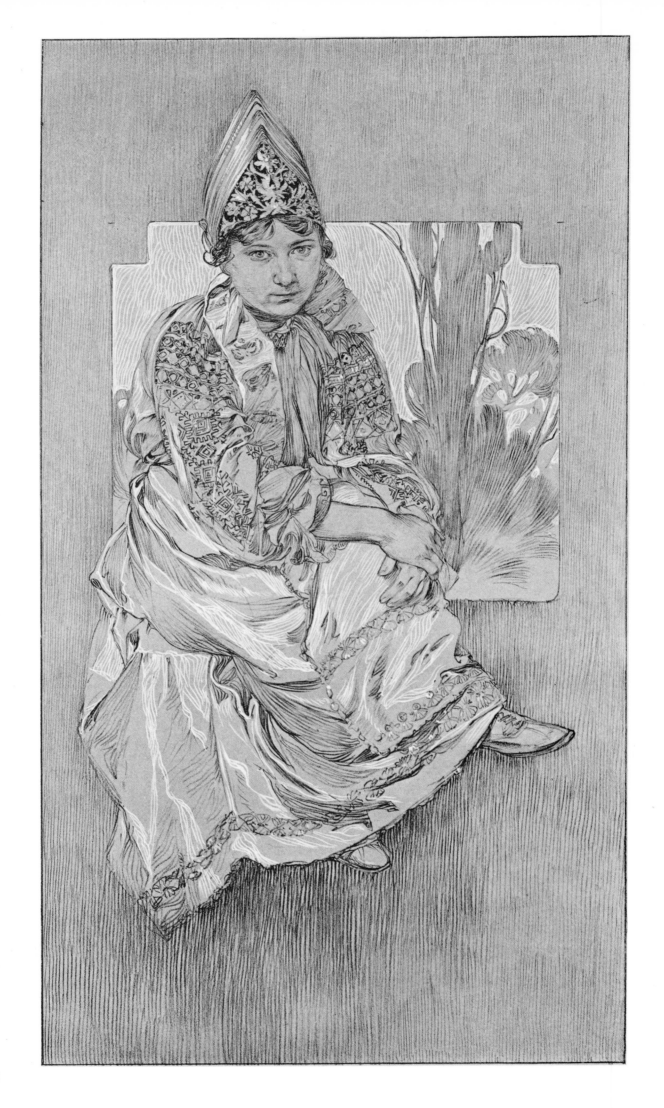

PLATE 8

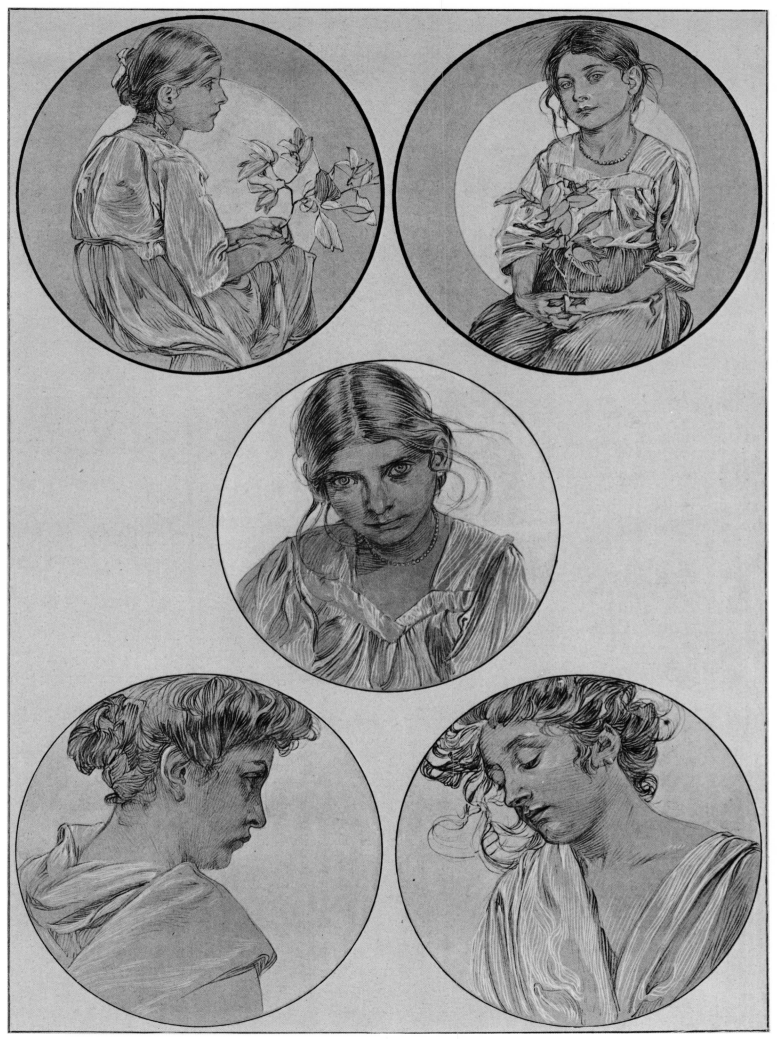

Plate 9

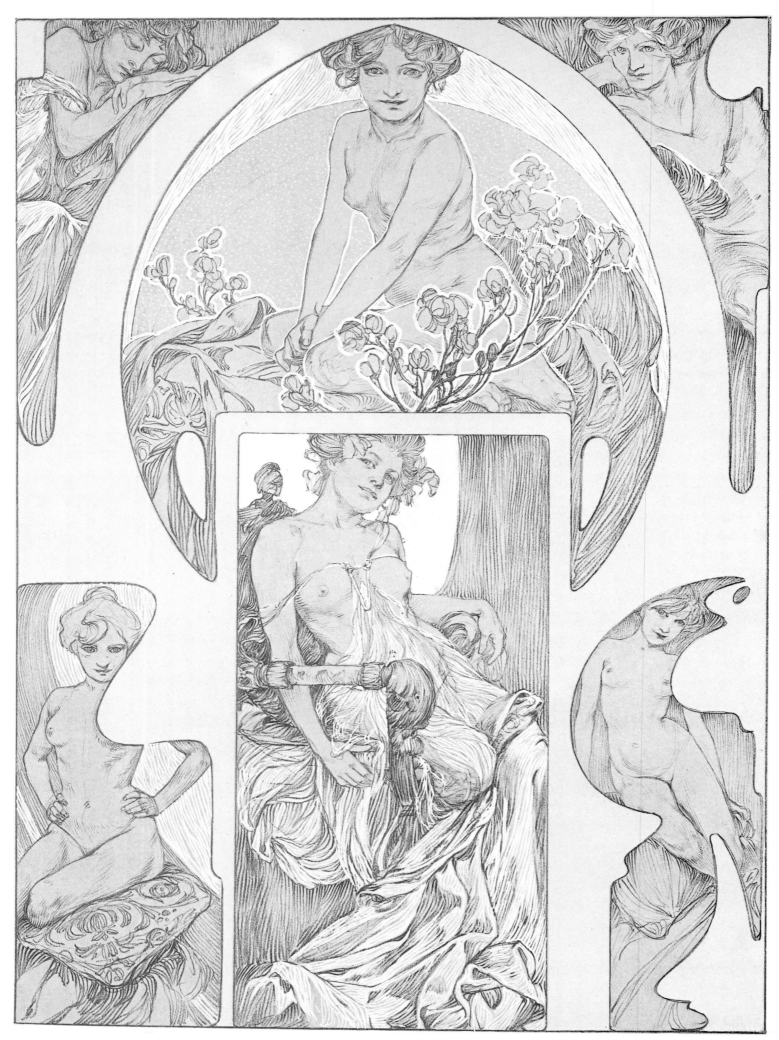

PLATE 10

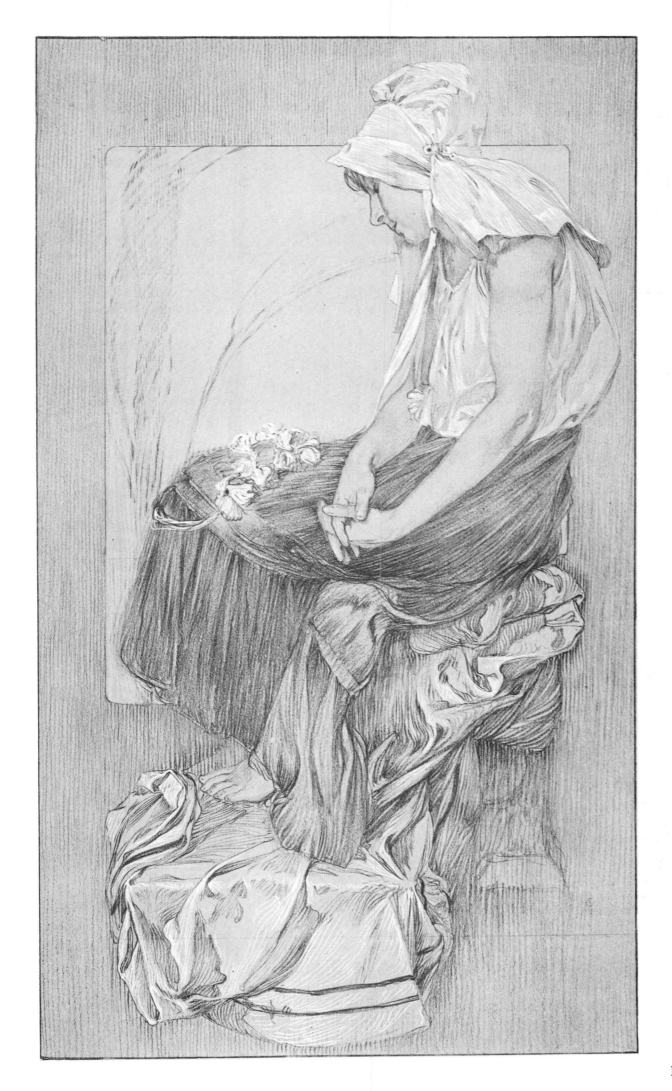

PLATE 11

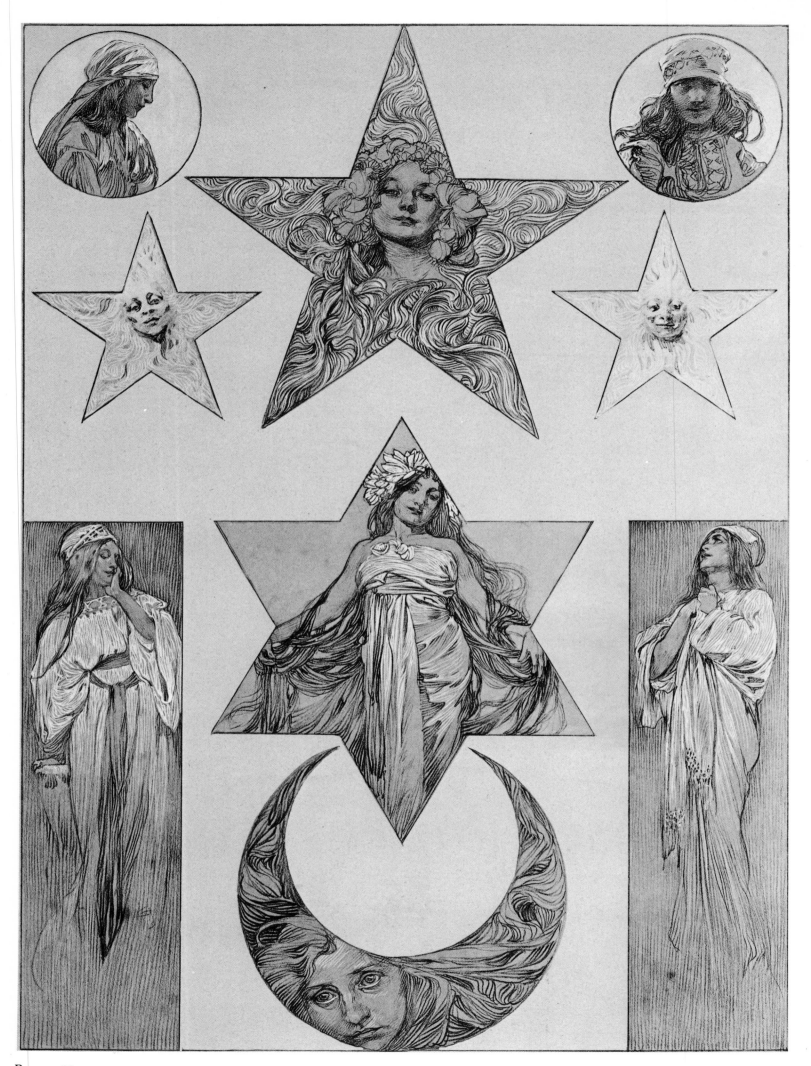

PLATE 12

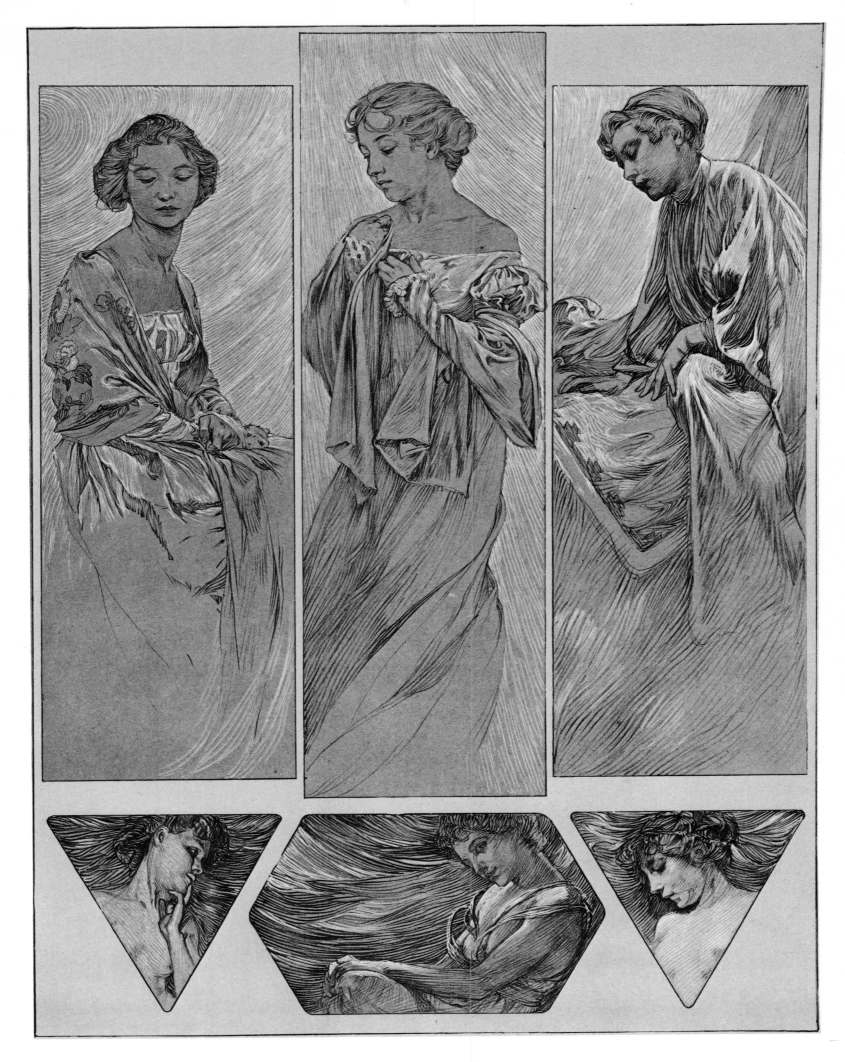

PLATE 13

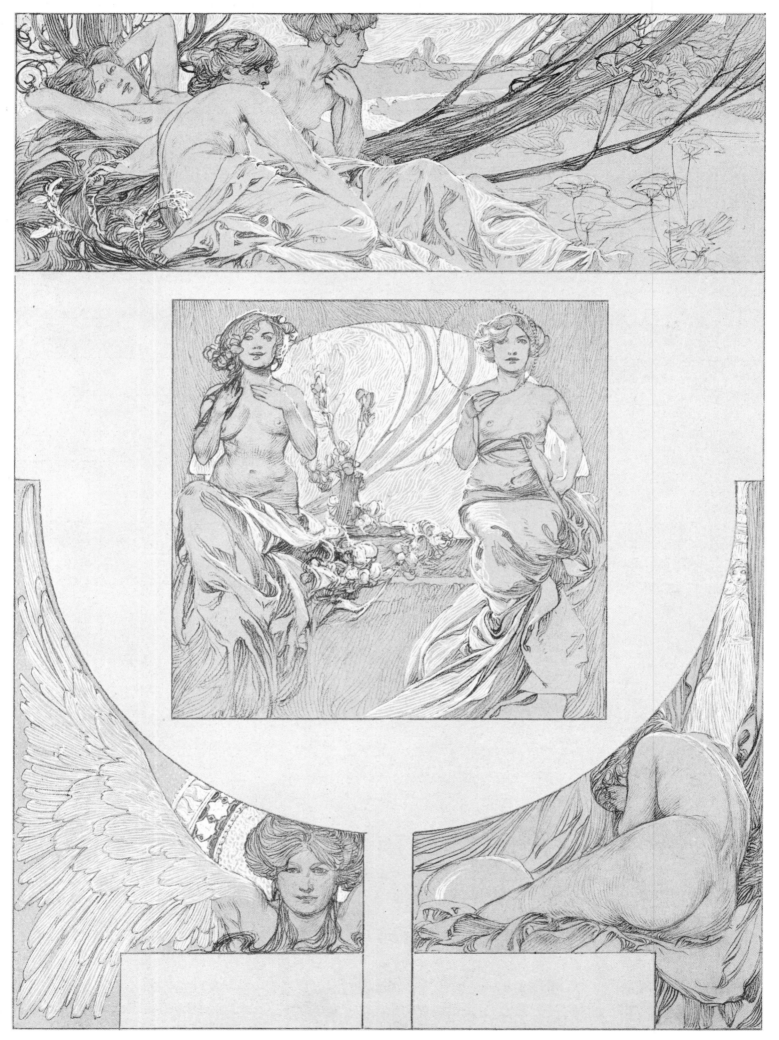

PLATE 14

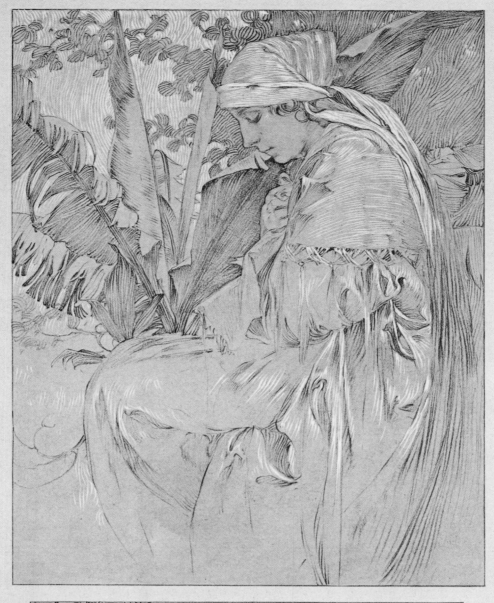

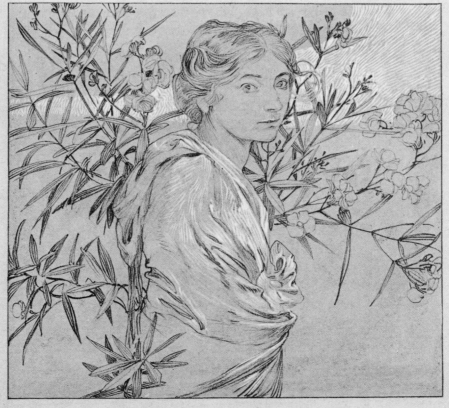

PLATE 15

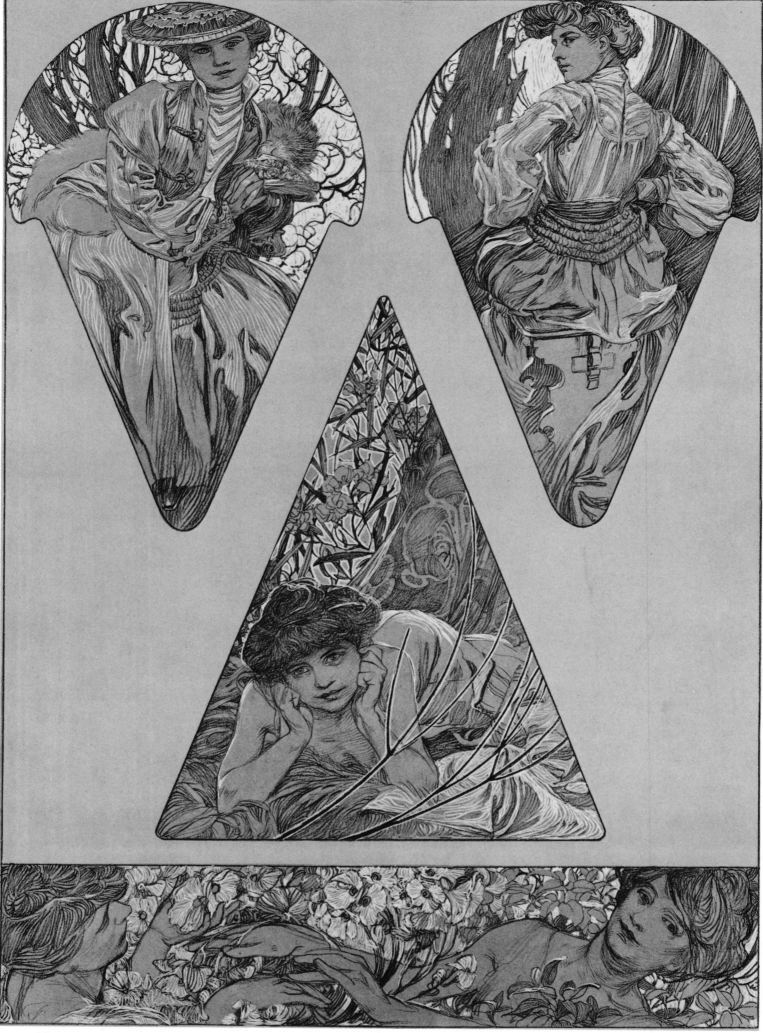

PLATE 16

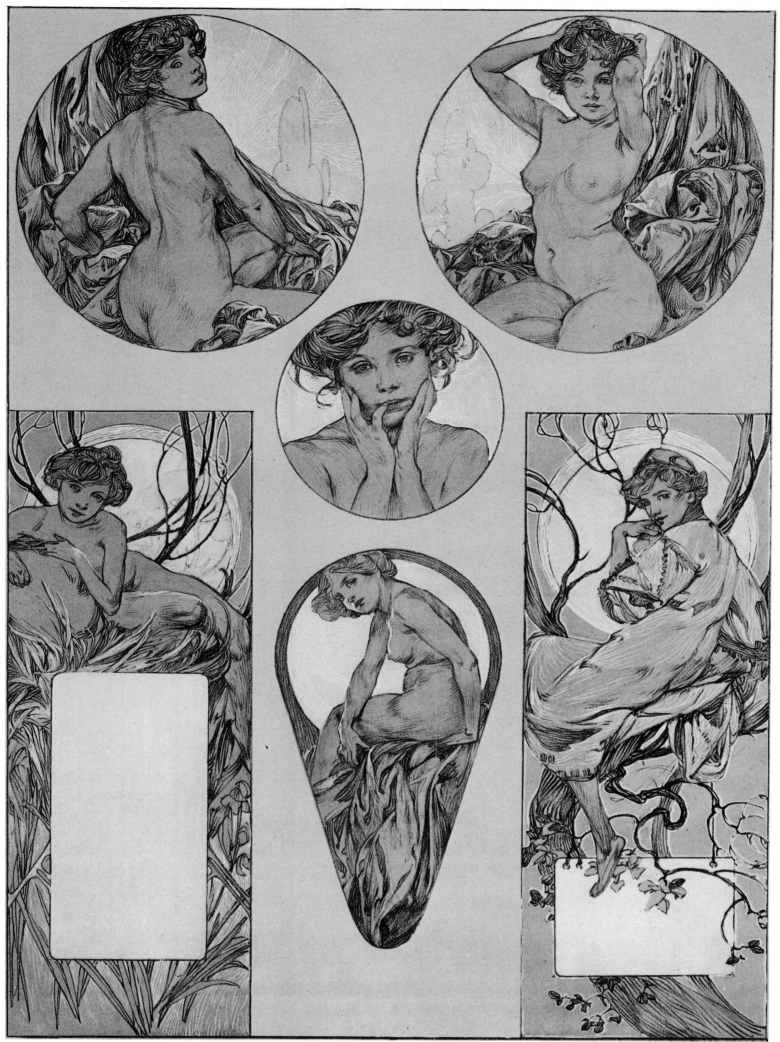

PLATE 17

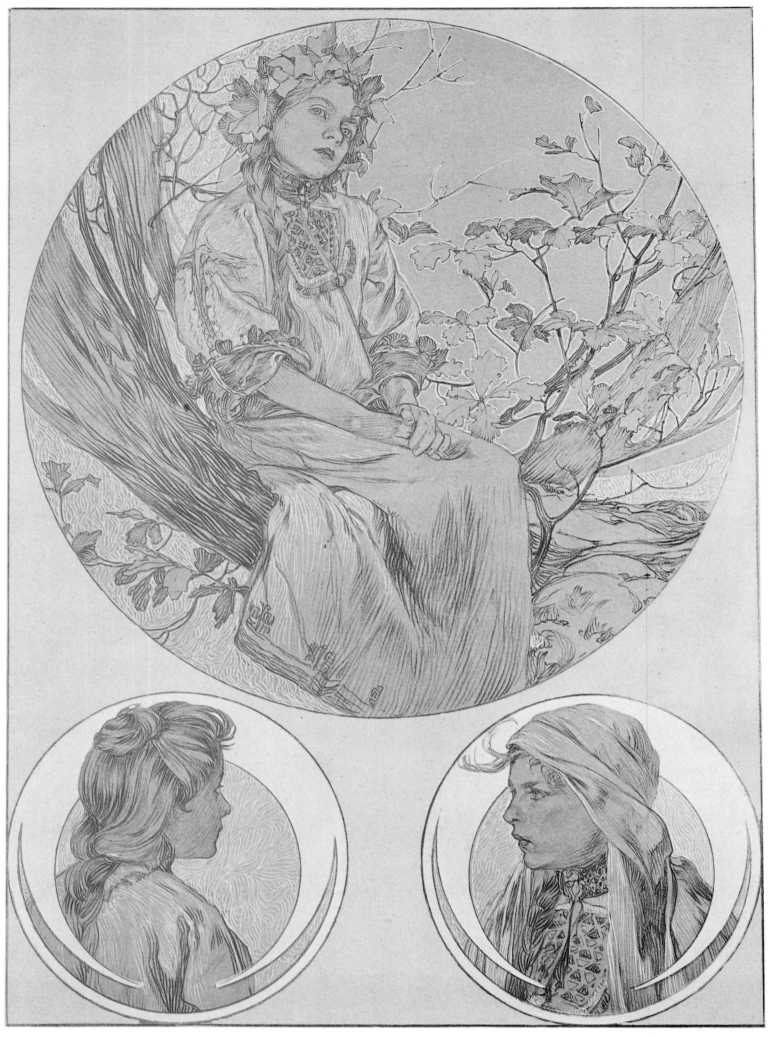

PLATE 18

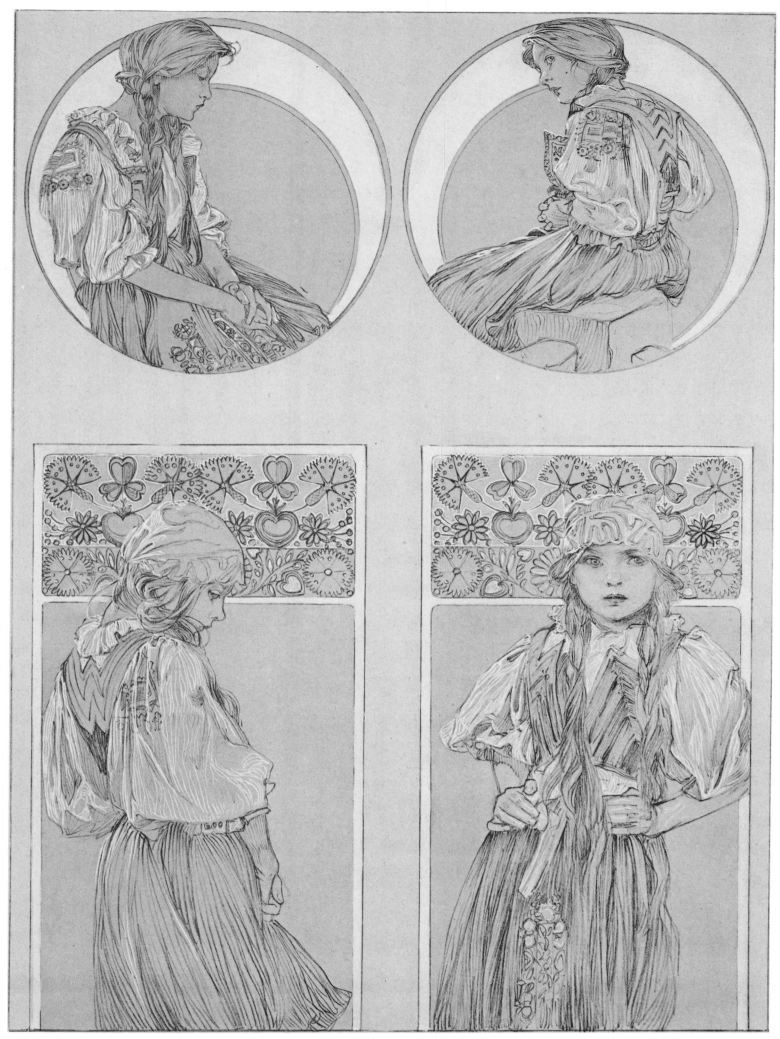

PLATE 19

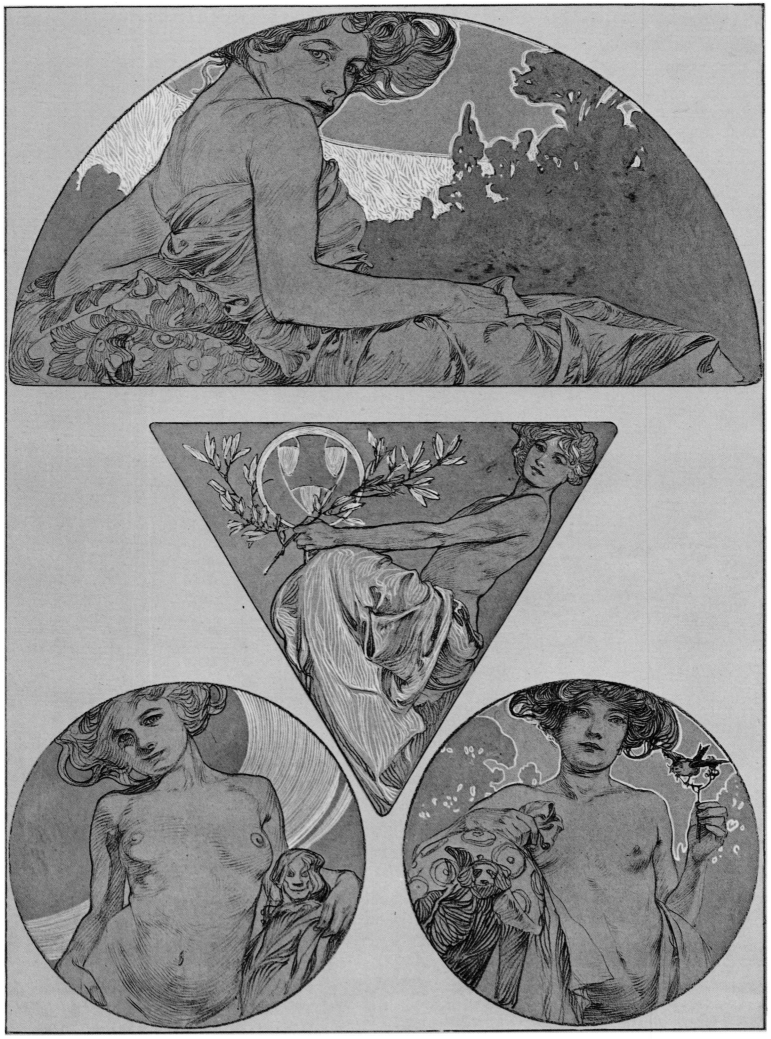

Plate 20

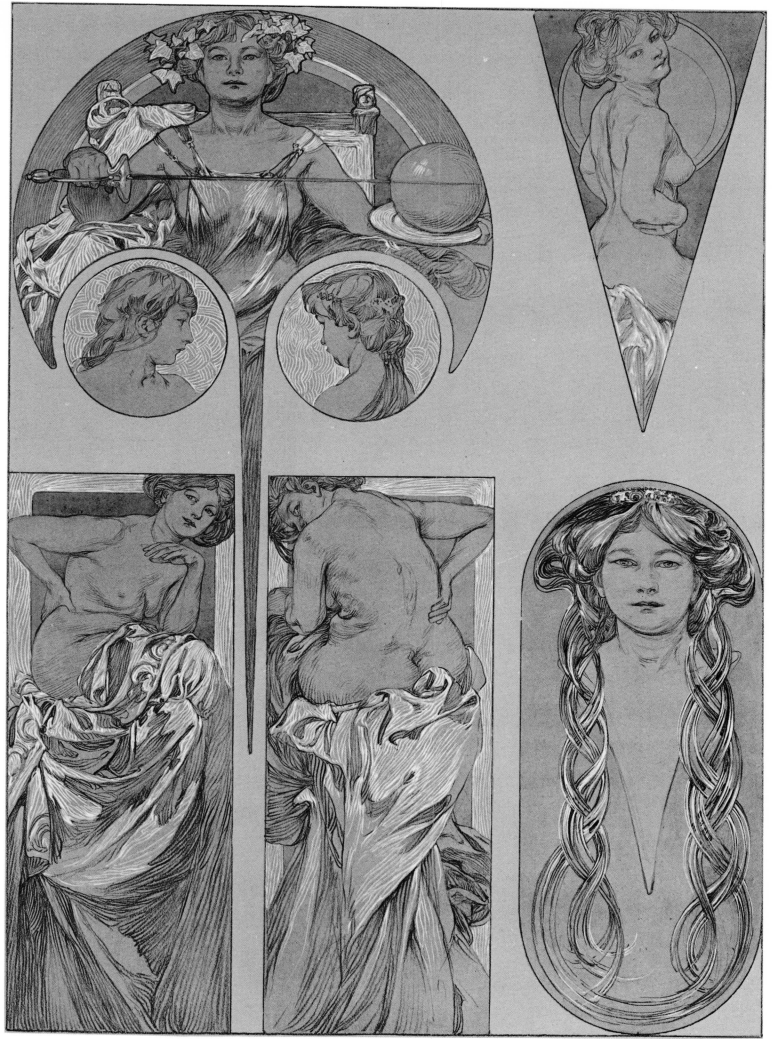

PLATE 21

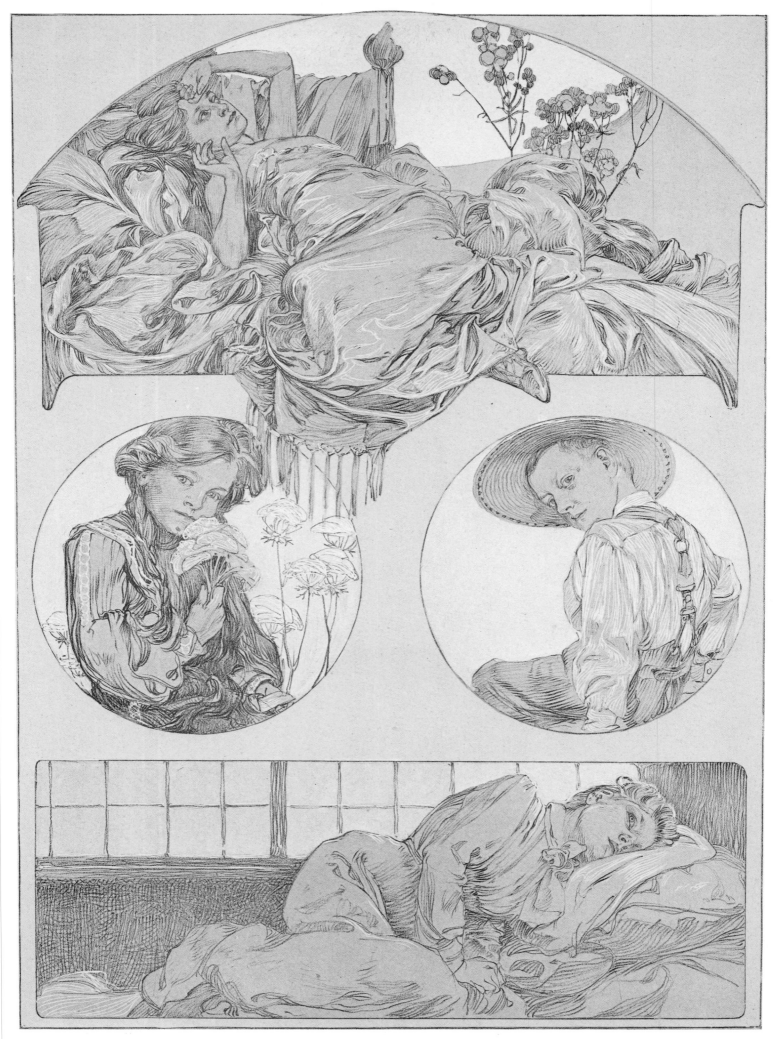

PLATE 22

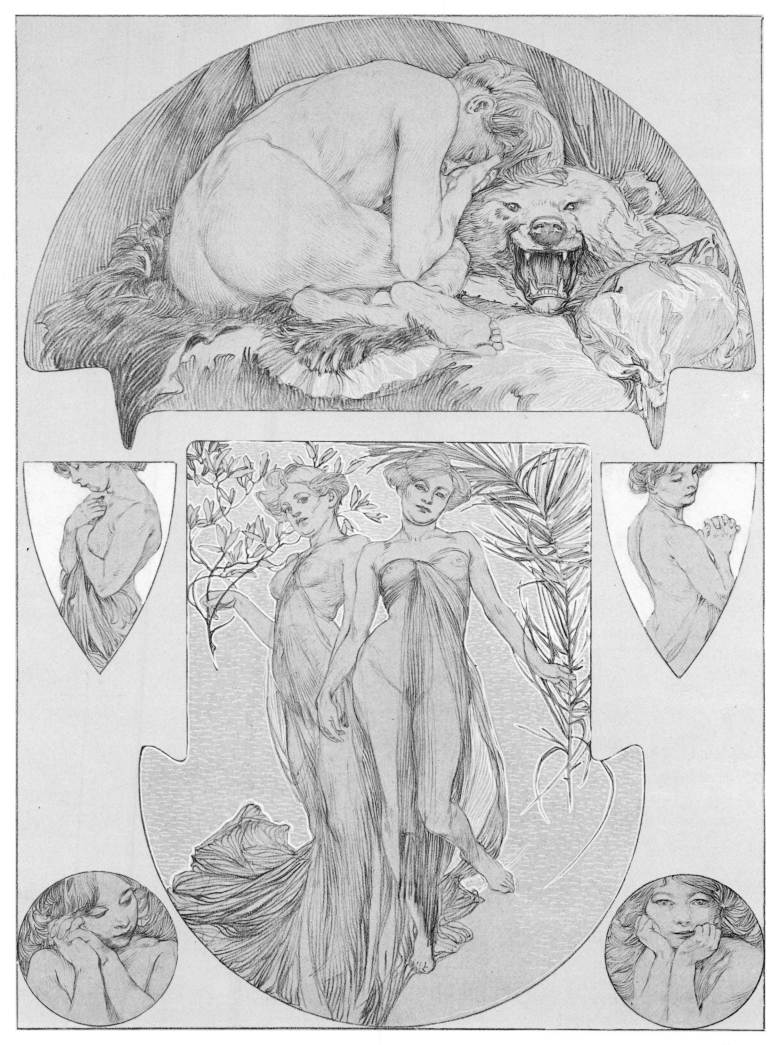

PLATE 23

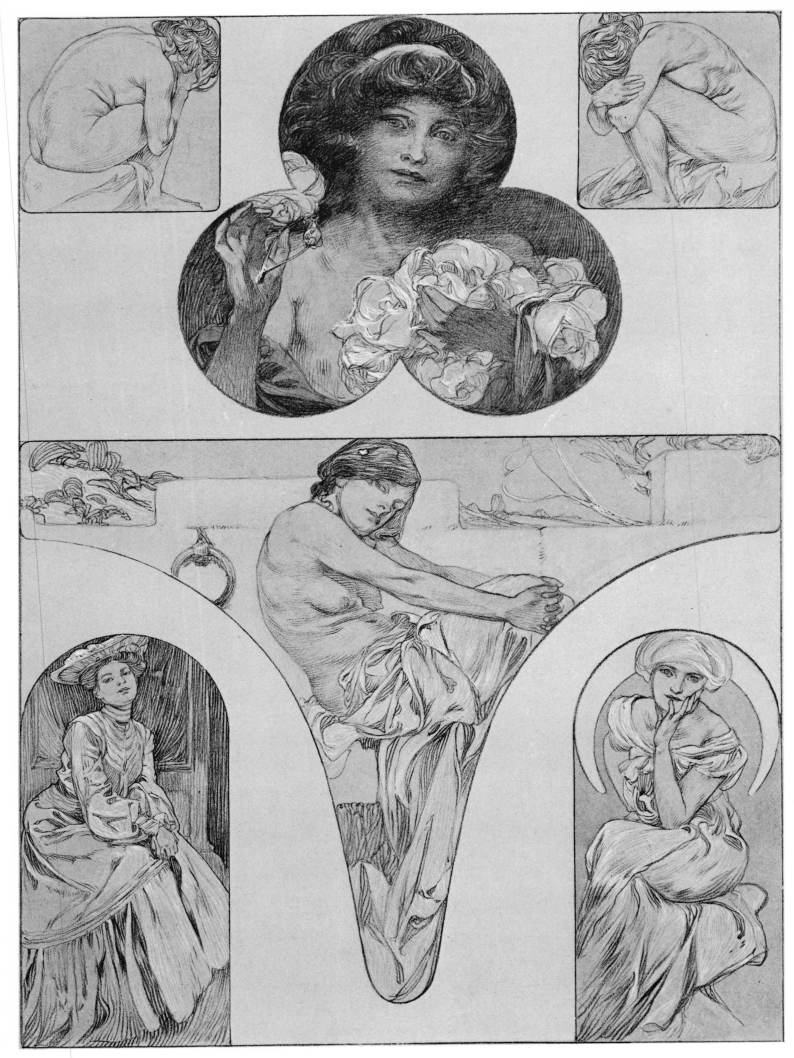

PLATE 24

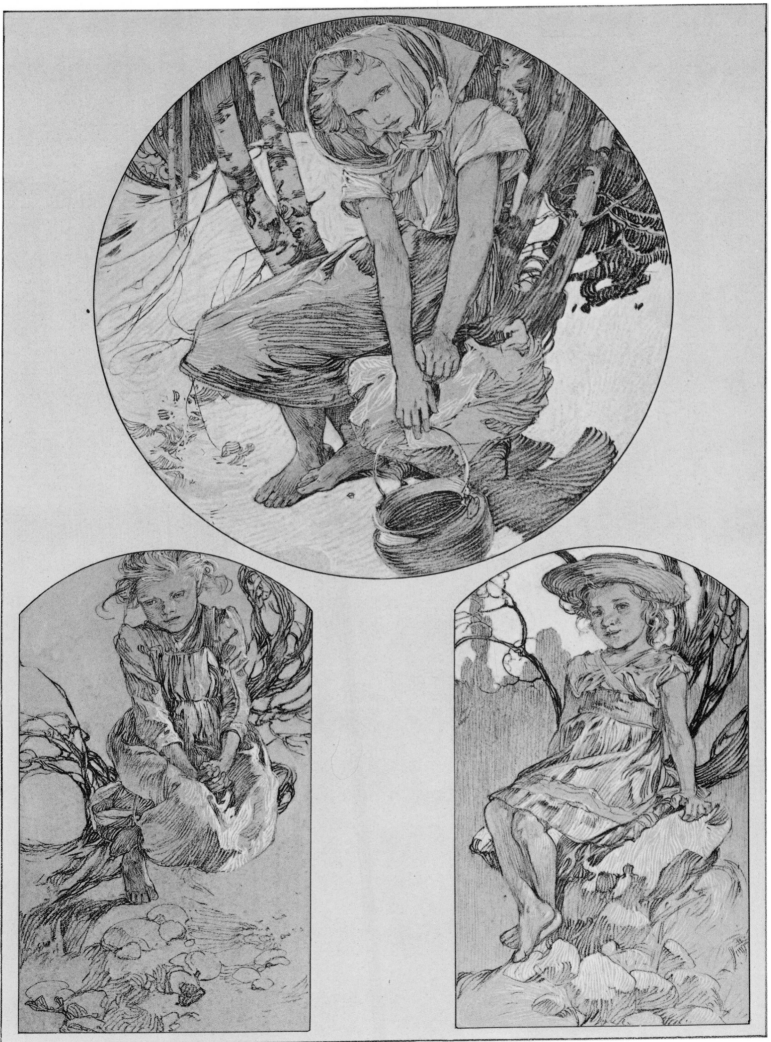

Plate 25

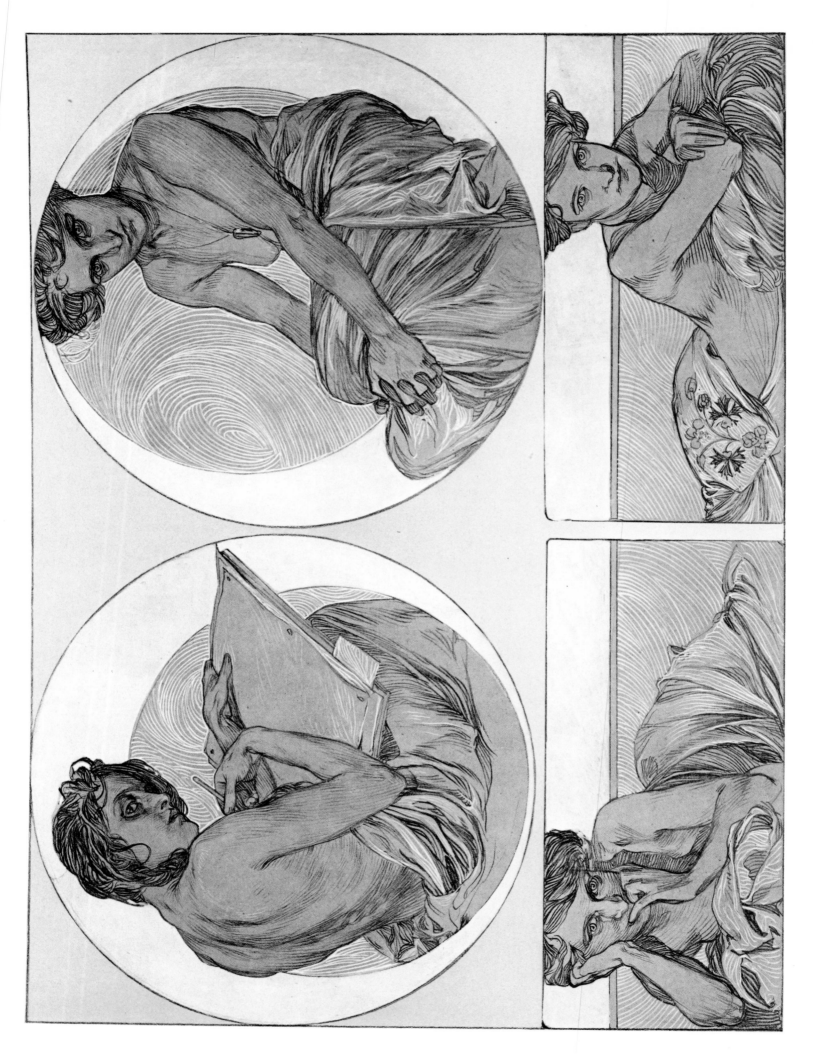

PLATE 26

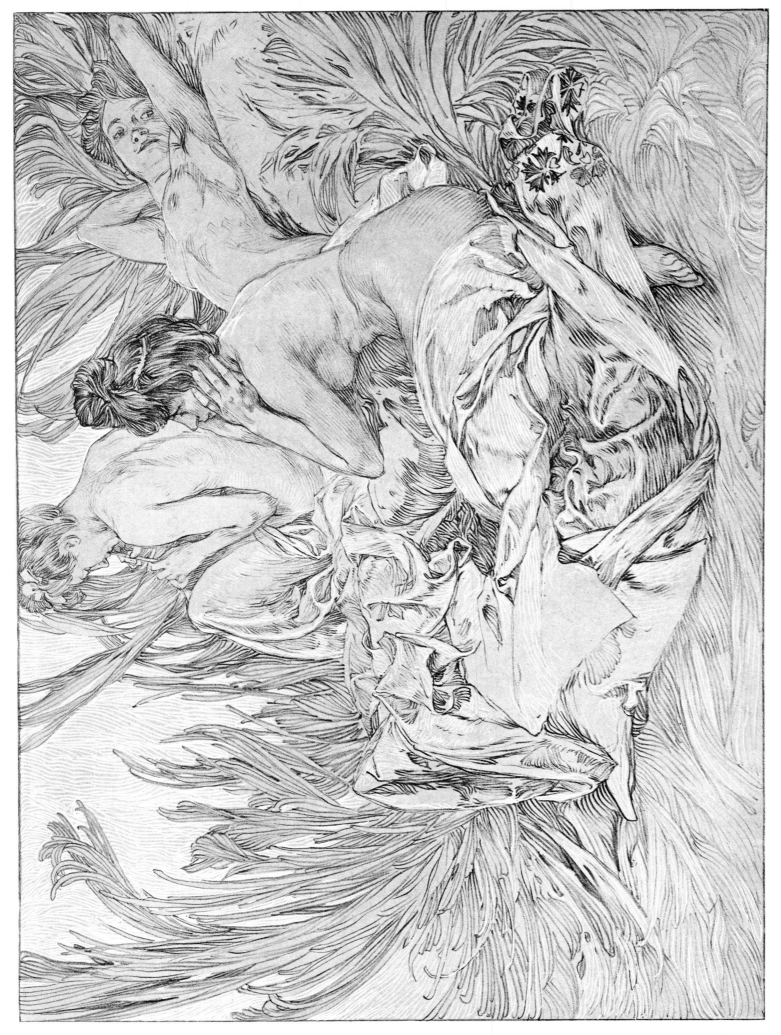

Plate 27

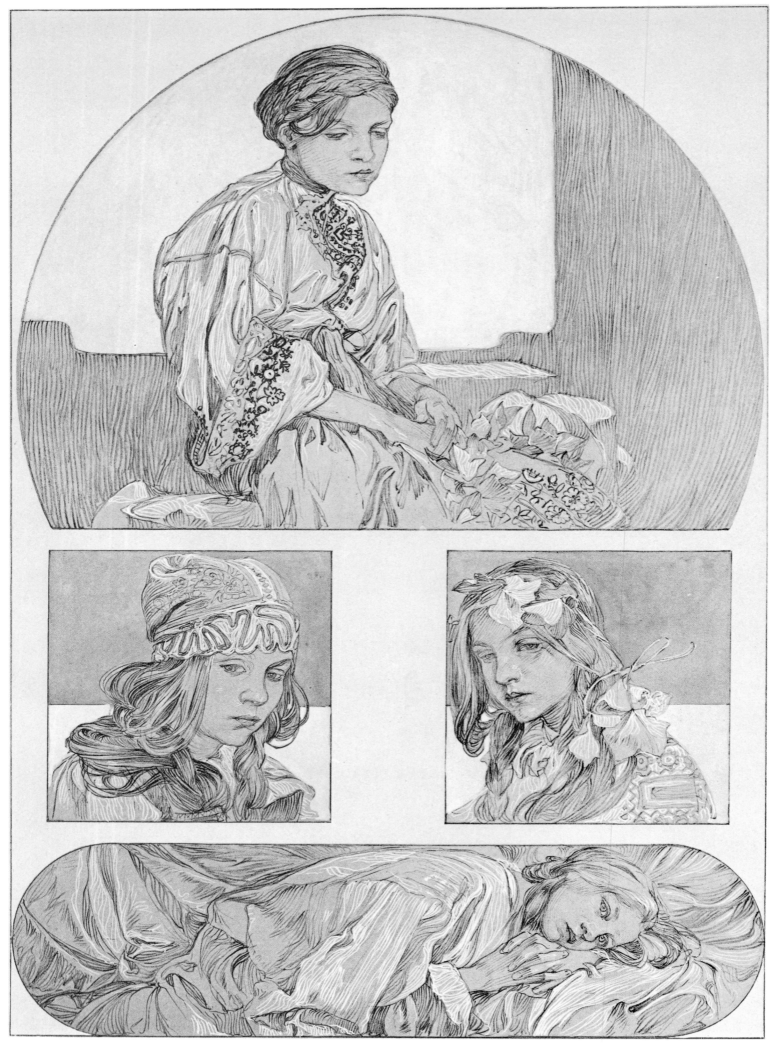

PLATE 28

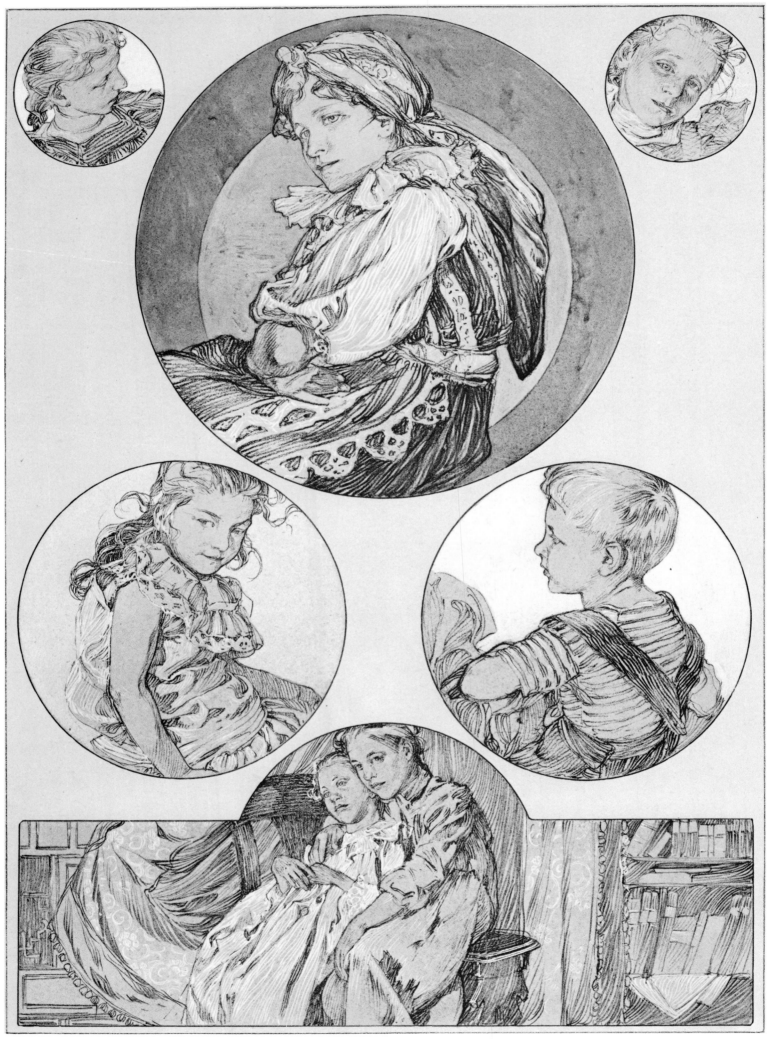

PLATE 29

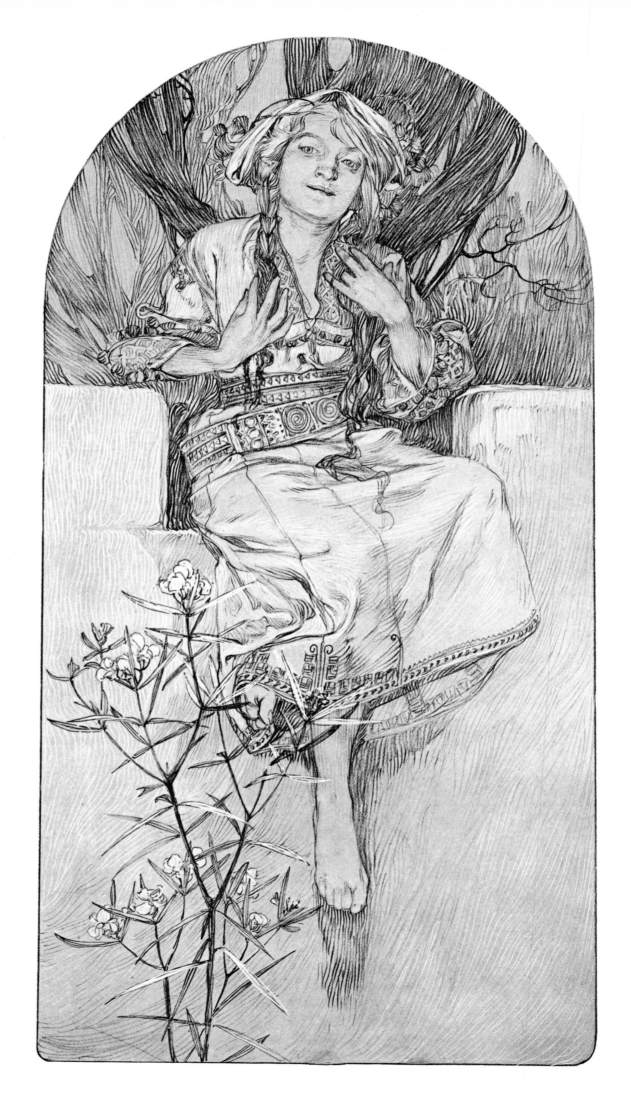

PLATE 30

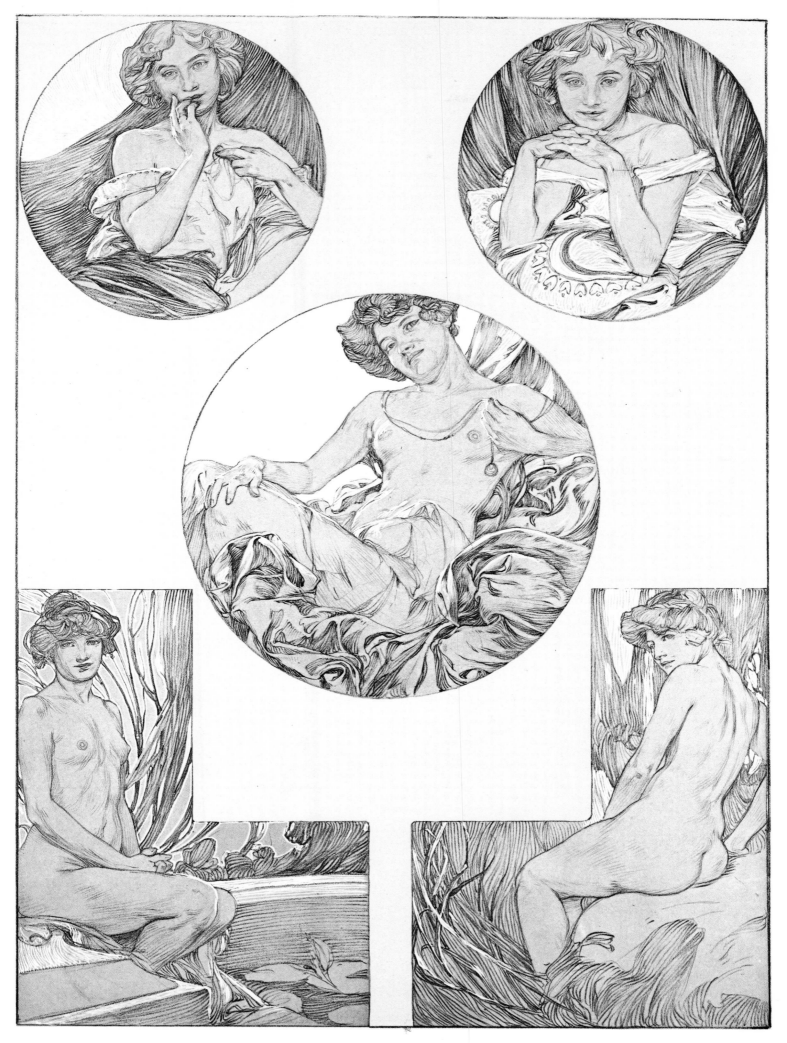

PLATE 31

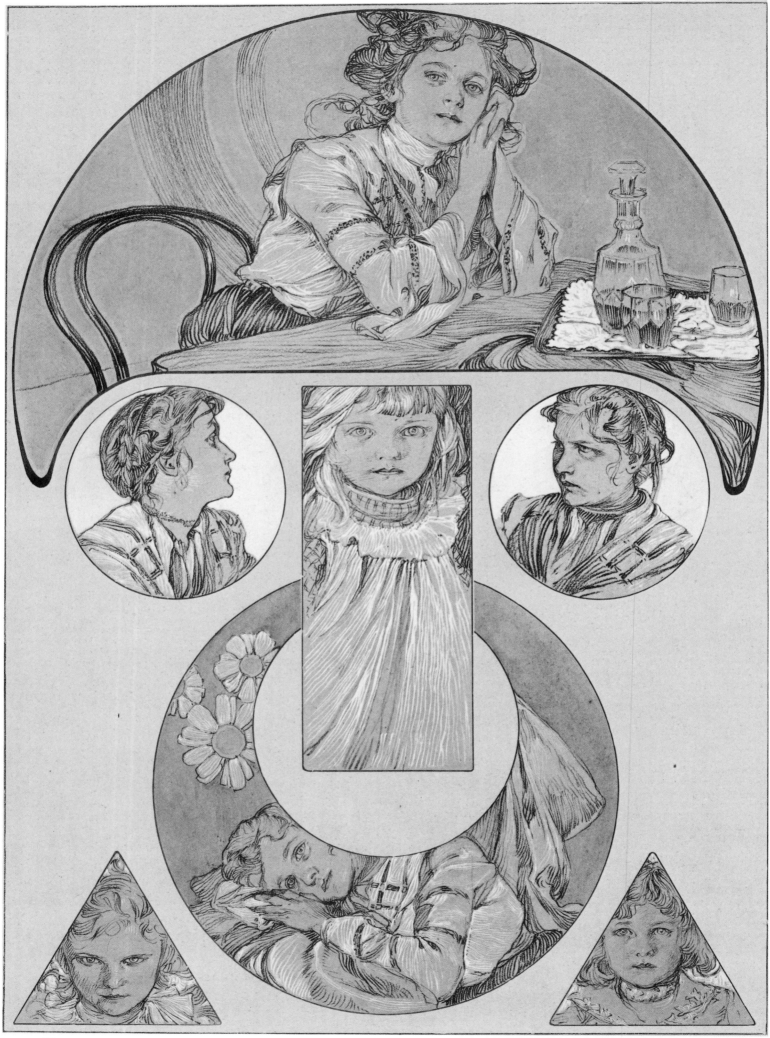

PLATE 32

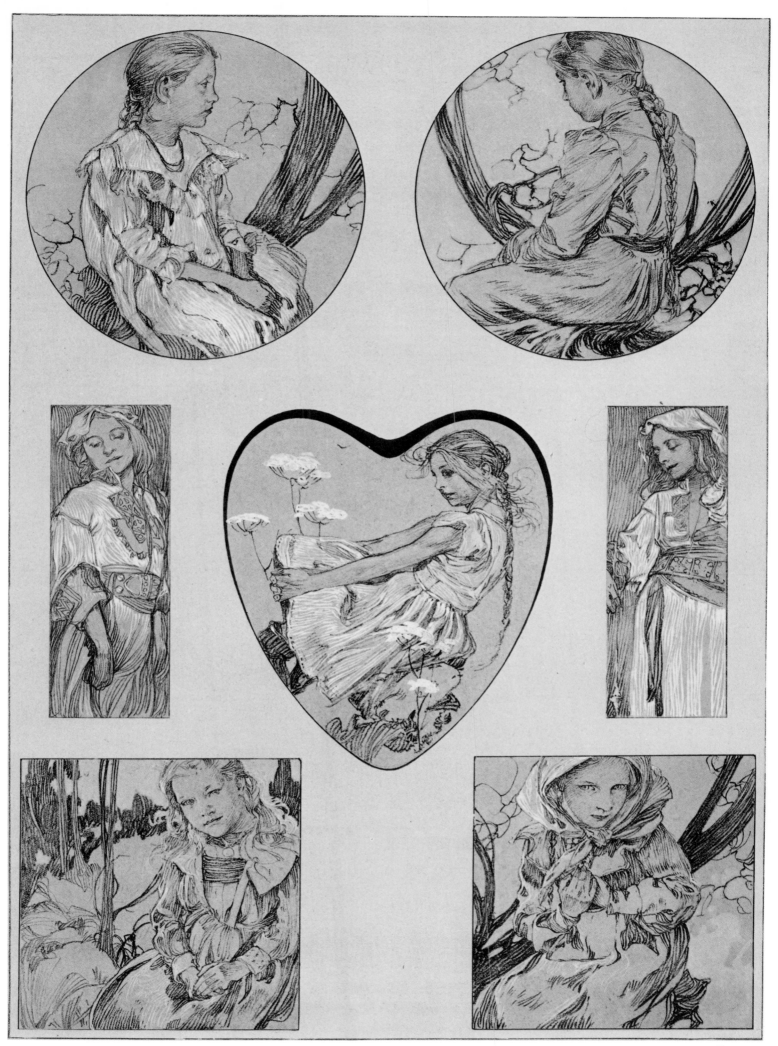

PLATE 33

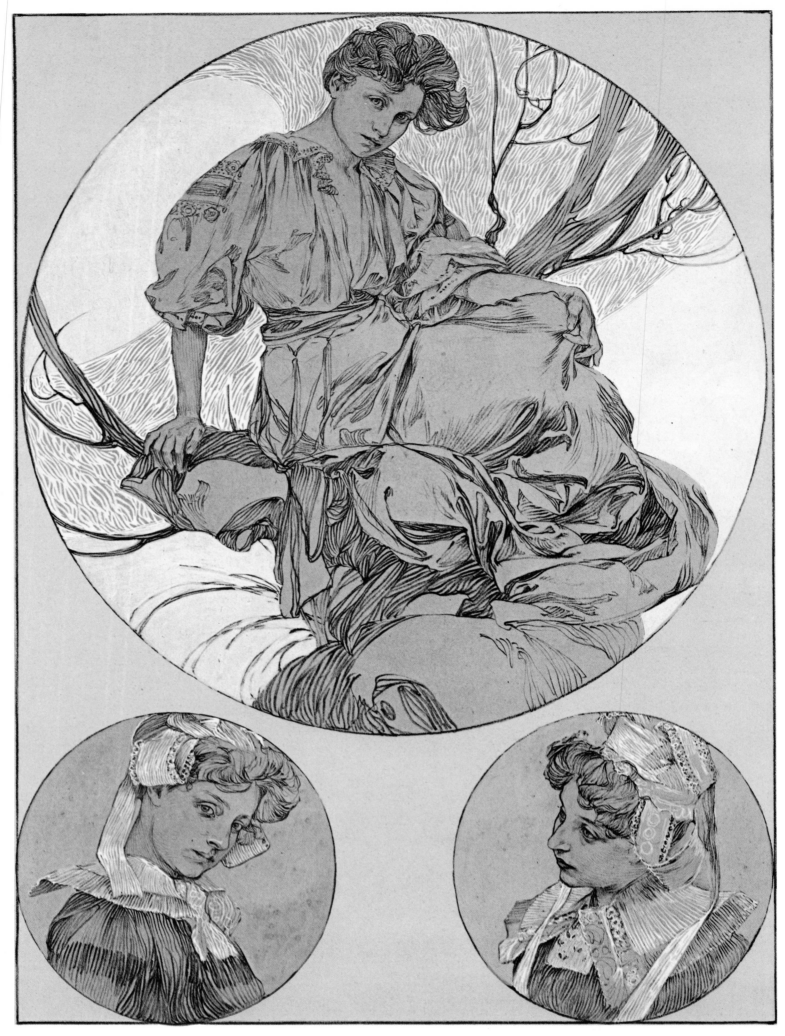

PLATE 34

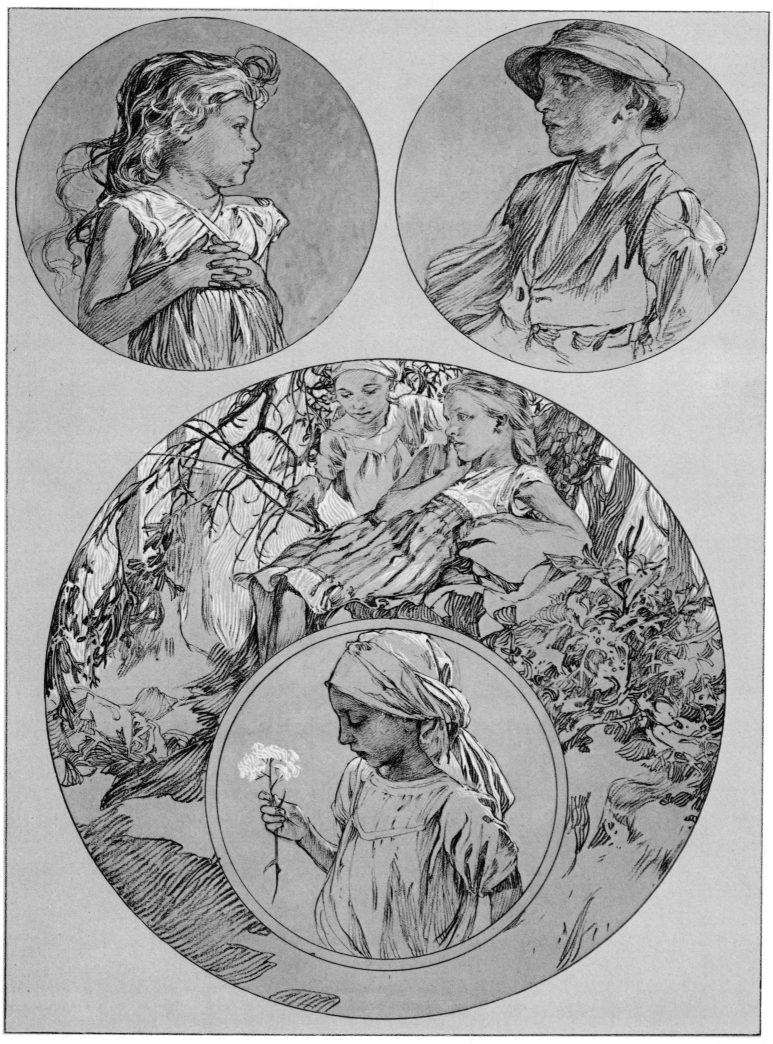

PLATE 35

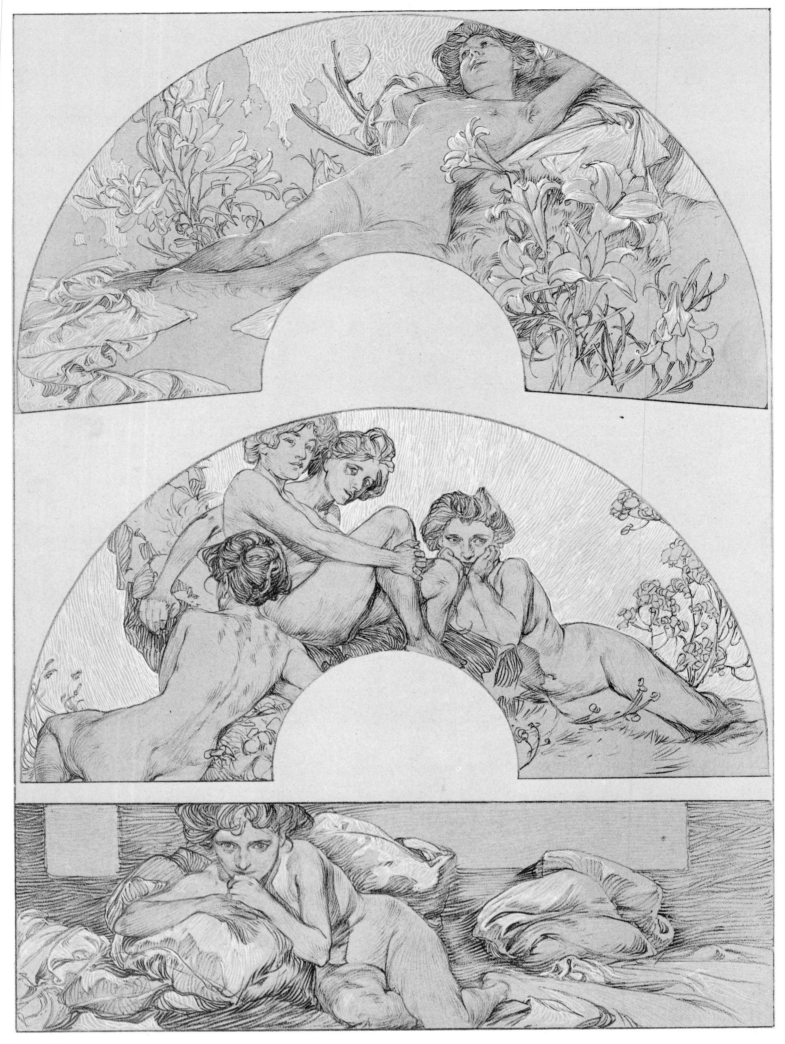

PLATE 36

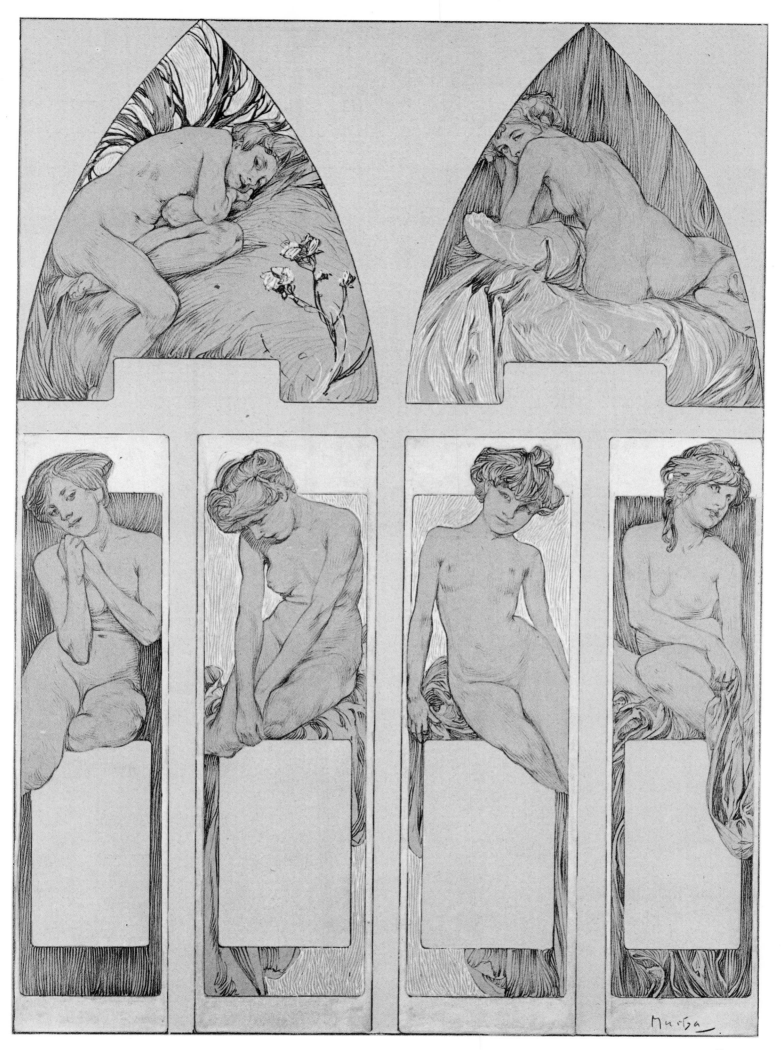

PLATE 37

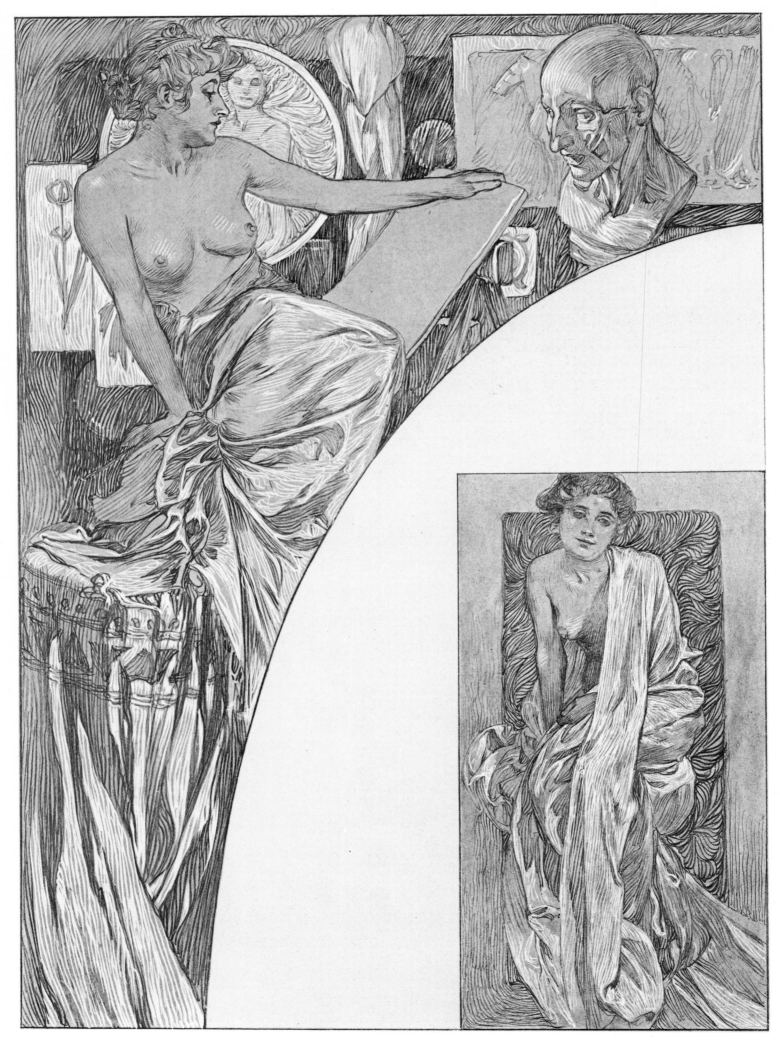

PLATE 38

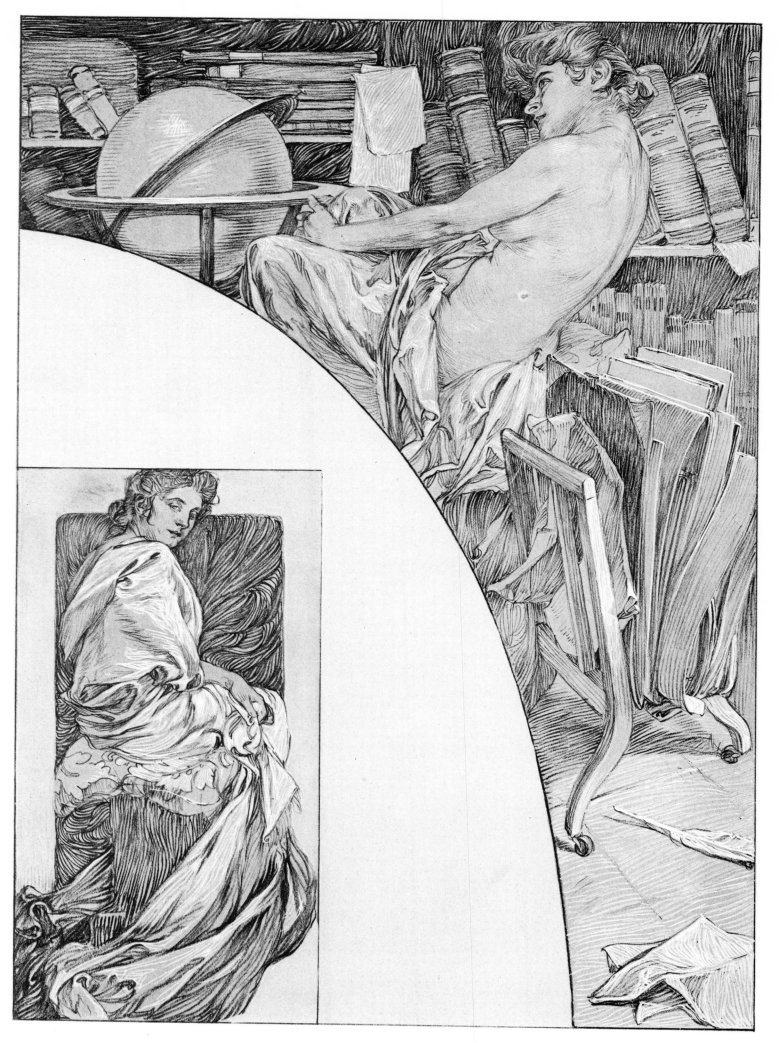

PLATE 39